J. Ensor

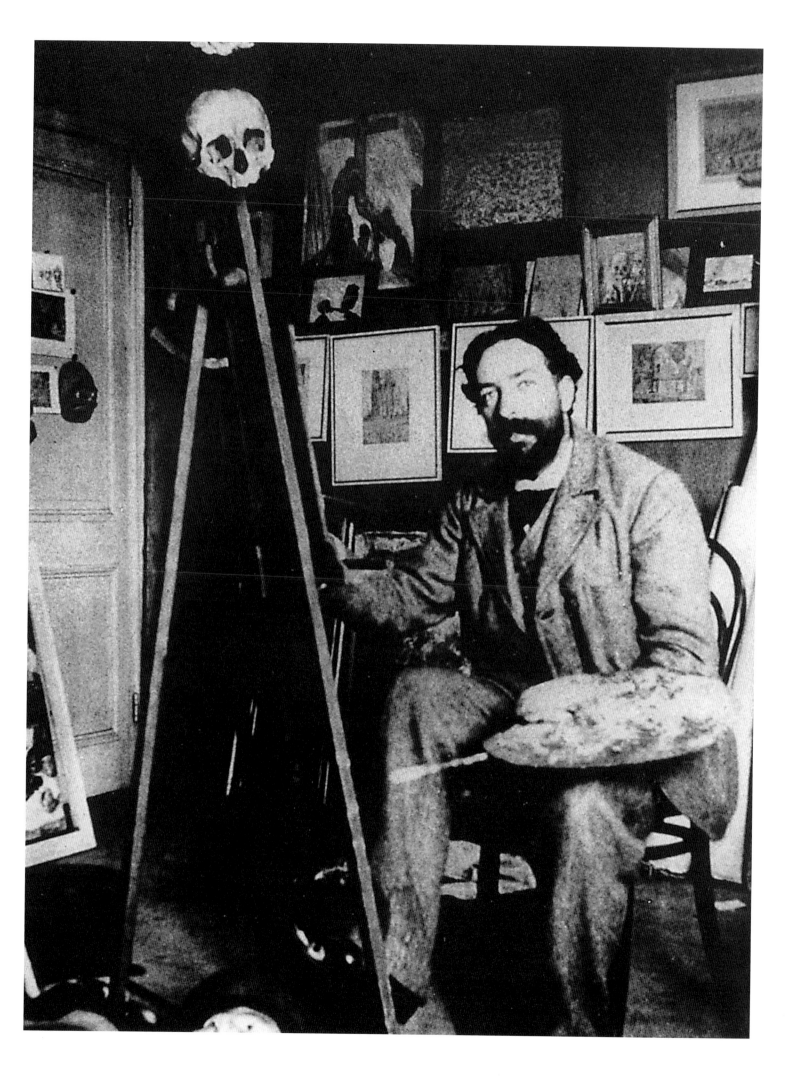

Ulrike Becks-Malorny

JAMES ENSOR
1860–1949

Masks, Death, and the Sea

KÖLN LONDON MADRID NEW YORK PARIS TOKYO

COVER:
The Intrigue (detail), 1890
Oil on canvas, 90 x 150 cm
Antwerp, Koninklijk Museum voor Schone Kunsten

ILLUSTRATION PAGE 1:
Row of Masks (detail), 1885
Contés crayons on paper, 22.4 x 17.5 cm
Antwerp, Koninklijk Museum voor Schone Kunsten

ILLUSTRATION PAGE 2:
Ensor in his studio, c. 1897

BACK COVER:
James Ensor, c. 1925

© 1999 Benedikt Taschen Verlag GmbH
Hohenzollernring 53, D–50672 Köln
© 1999 VG Bild-Kunst, Bonn, for the works by James Ensor
Coordination: Michael Konze, Cologne
Production: Ute Wachendorf, Cologne
English translation: John Gabriel, Worpswede
Cover design: Angelika Taschen, Cologne

Printed in Germany
ISBN 3-8228-7026-9

Content

6

Outsider and Loner

26

Between Realism and Imagination

42

Parade of the Masses

56

Behind the Mask

72

Hareng Saur – Satire and Caricature

86

Baron Ensor – Late Fame

94

Life and Work

Outsider and Loner

There is hardly another artist of the fin de siècle whose work is as various, bizarre, and open to so many interpretations as that of the Belgian artist James Ensor. As he himself recognized, he was "an exceptional phenomenon" as a painter. Though Ensor lived until 1949, his oil paintings and prints really belong to the late nineteenth century: the major phase of his œuvre spanned the years 1885 to 1895, when he was between twenty-five and thirty-five. His reputation as a limner of eerie, bizarre masks and masqueraders was established during his lifetime. Yet his landscapes and still lifes, not to mention his extraordinary achievements in the field of graphic art, even today remain to be discovered by a wider audience.

As eccentric as he was unorthodox, Ensor worked largely in isolation from the main streams in art at that period, which were influenced above all the realism of Gustave Courbet and the landscapes painted in the open air by Claude Monet and the other French Impressionists. Ensor's pictures, in contrast, were highly and nervously expressive, often phantasmagorical, and at times they could be positively garish and aggressive. His entirely subjective view of the world and the things and people that jostle for attention in it influenced numerous artists of the twentieth century, especially Emil Nolde, Paul Klee, George Grosz, and Alfred Kubin. Who was this creator of a fantastic universe that triggered so much controversy during his lifetime, this retiring man whose diverse and challenging œuvre is still capable of provoking audiences jaded by decades of exposure to consciously provocative modern art?

Ensor With Flowered Hat (p. 9), a self-portrait of 1883 reworked in 1888, exudes self-confidence, almost hauteur, and the eyes seem to fix his imagined interlocutor with critical detachment. Five years after finishing the original version of the portrait, the artist added the hat decorated with plume and wreath of flowers, the twirled moustache ends, and the suggestion of a round mirror frame: all allusions to a similar self-portrait by Peter Paul Rubens (1577–1640), the great master of the Flemish Baroque. Did Ensor mean to match his skills against those of his admired compatriot? Or was he parodying Rubens – or perhaps himself into the bargain? Some twenty years later, in 1911, Ensor would confidently call himself brilliant and unique, and add that he had "anticipated all modern tendencies... in every direction." Evidently he thought himself one of the greatest contemporary painters in Flanders, a painter who, as much as Rubens, had carved out for himself an outstanding place in the world of Belgian art. But his later self-portraits present a different picture. His face reflects disappointment, occasionally even bitterness, anxiety, premonitions of death. The self-assured, proud, humorous air of the earlier works has vanished entirely.

James Ensor was born on April 13, 1860, in Ostend, a resort town on the North Sea coast of Belgium. He grew up in a country whose monarchy was just thirty years old, where the church was struggling for influence and rapid industrial

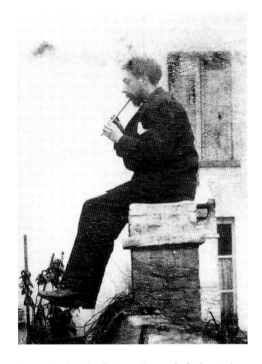

Ensor playing the flute on the roof of a house in Ostend (detail), c. 1881

PAGE 6:
Carnival in Flanders (detail), after 1920
Oil on wood panel, 27 x 36 cm
Zurich, Kunsthaus Zürich

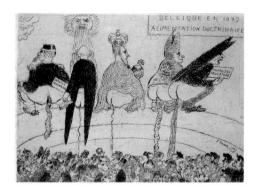

Doctrinaire Nourishment, 1889
Etching on Japan, 17.6 x 24.5 cm
Collection Mira Jacob, Paris

The king and his vassals "feeding" the people, that is, indoctrinating them in the most debased manner imaginable, which the people not only do not question but appear positively to enjoy. An irreverent, biting caricature on the subject of blind faith in authority.

PAGE 9:
Ensor with Flowered Hat, 1883–1888
Oil on canvas, 76.5 x 61.5 cm
Ostend, Museum voor Schone Kunsten

This enigmatic self-portrait, both realistic and imbued with fantasy, is one of Ensor's early masterpieces. The self-absorbed, proud gaze indicates the assurance with which the artist measured himself against Rubens, the most re-nowned painter of the Flemish Baroque. The hat, twirled moustache, and suggestion of a round mirror frame were added five years later, when, under the influence of Impressionism, Ensor began using lighter colors.

The Flemish Flats Seen from the Dunes, 1876
Oil on cardboard, 23.5 x 31.5 cm
Private collection

Before entering the Brussels Academy Ensor painted a series of small-format pictures on card-board which he had found in his mother's shop. In retrospect he wrote, "At fifteen I painted views of the environs of Ostend from nature; these humble little pictures, painted in oil on pink cardboard, still delight me even now."

development was exacerbating social tensions between the two main population groups, Flemish and Walloons, who were divided by both linguistic and histori-cal barriers. In his art Ensor would again and again address the political, socio-economic, and ethnic divisions in Belgium and the shifting power relationships these entailed. His sometimes entirely disrespectful treatment of established authorities shocked even his friends and acquaintances. An etching such as *Doctrinaire Nourishment* is a typical if especially drastic example of Ensor's view of current politics, which can only be termed anarchist. The painting shows King Leopold II and representatives of military, church, and government crouched on a raised ramp, regaling the eager, open-mouthed crowd below with their feces.

Ensor spent nearly all of his life in Ostend. In the winter months a rather sleepy harbor town of 16,000, in summer Ostend metamorphosed into a fashion-able bathing resort that was frequented by Belgian royalty and attracted the cream of European, especially English, society. Ensor's father, James Frederic Ensor, had studied medicine in Bonn, spoke several languages, and was an accomplished musician. In later years he would be the only member of the fam-ily to follow his son's artistic career with interest and sympathy. After a period in the United States and despite repeated failures to establish himself profession-ally in Ostend, James Frederic persisted in staying on, and soon married a local girl. The couple's social backgrounds were very different. Maria-Catharina Haegheman, Ensor's mother, was of humble origin. Her parents, who had never learned to write, traded in Brussels lace; her brother was a shellfish monger. With her sister, Mimi, Maria-Catharina ran a shop dealing in souvenirs, sea-shells, diverse exotic paraphernalia, and carnival articles such as masks, tinsel, novelties, and costumes. This shop, stuffed, to bursting with the most amazing things, where even as an adult Ensor continued to help out as a clerk during the busy summer season, fired the boy's imagination. Later he would recall that his childhood was spent "... in the midst of gleaming, mother-of-pearl-colored shells with dancing, shimmering reflections and the bizarre skeletons of sea monsters and plants. This marvellous world full of colors, this superabundance of reflec-tions and refractions made me into a painter who is in love with color and is delighted by the blinding glow of light."

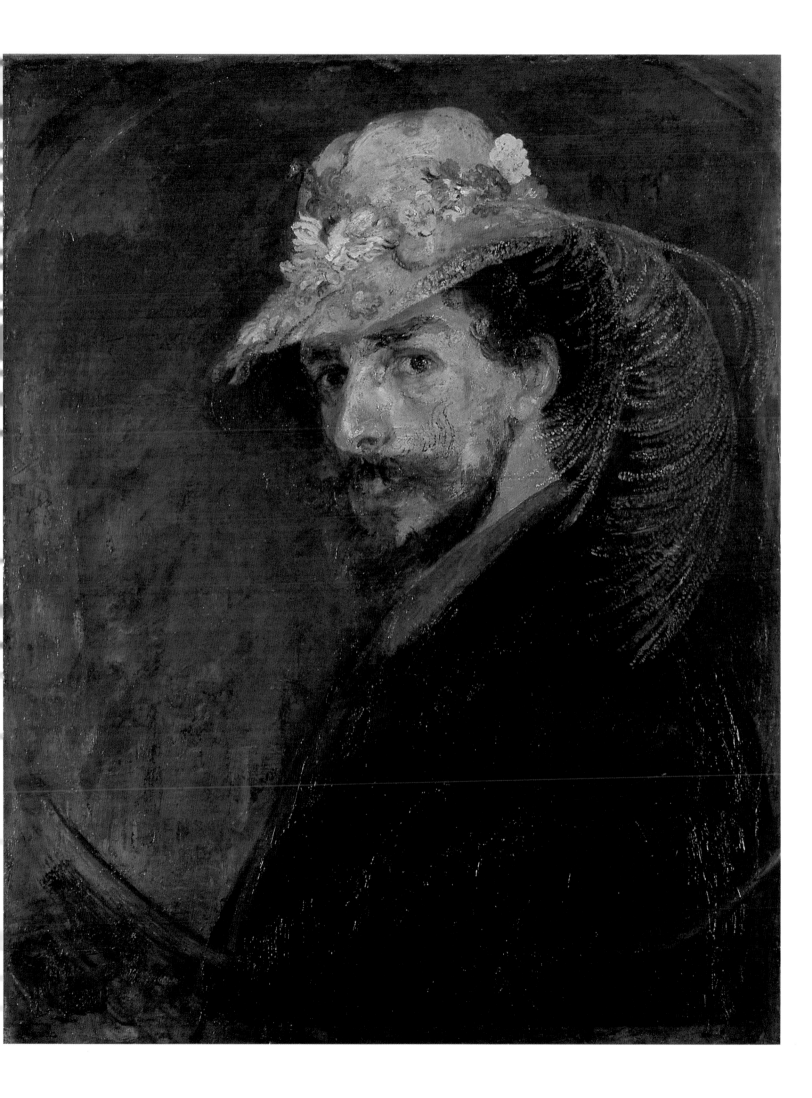

The Pisser, 1887
Etching on Japan, 14.5 x 10.3 cm
Collection Mira Jacob, Paris

In the course of his career Ensor made a few hundred copies, or adaptations, of etchings by Old Masters. In this case he used a popular motif of Jacques Callot (1592–1635) to reflect on his own situation as an artist derided by the public.

For Ensor's father, a product of the well-to-do British upper middle class, a tall and imposing man whom his son both feared and worshipped, helping out in the shop was unthinkable. He preferred to while away the day in his fine library, or sit in a café and watch the world go by. In the eyes of petty-bourgeois Ostend he was an idler and a failure, a drinker whose airs only made himself look ridiculous. The absence of his father meant that young James spent his boyhood mostly among and under the influence of women: his mother, who spoiled him with sweets from the shop; his quarrelsome, eccentric Aunt Mimi, who used to walk her canary in its cage along the dyke; and his grandmother, lover of the Carnival, who ran the household with a strict hand. Along with a certain high-strung spleen, family life among the Ensors was apparently dominated by harshness, emotional coldness, and mutual mistrust. Perhaps this is the reason why Ensor,

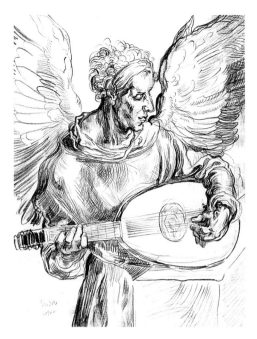

Seraphim with Lute, c. 1877
Pencil on paper, 22.5 x 17 cm
Antwerp, Koninklijk Museum voor Schone
Kunsten

This drawing was done after an etching by
Albrecht Dürer which was reproduced in 1877
in the French art journal *La Gazette des Beaux-
Arts.*

Bathing Hut, 1876
Oil on cardboard, 18 x 23 cm
Antwerp, Koninklijk Museum voor Schone
Kunsten

"To live in a big bathing hut whose interior is
clad in mother-of-pearl shells, and to sleep there,
cradled by the sound of the sea and an indolent
blonde beautiful girl with salty flesh," mused
Ensor in a letter to his friend Jules Dujardin.

abetted by decades of financial dependency, never married. Also, the failure of
the marriage of his sister Mitche, a year his junior, must have been anything but
encouraging. Her loose love life and her fondness of drink were a cause of great
concern to Ensor, not least because after his father's premature death in 1887, he
was the only man in the family and as such felt responsible for her.

Ensor's relation to women was shot through with contradictions. On the one
hand, he seems to have distrusted, even despised them: "Ah! The female and her
mask of flesh, living flesh, that justifiably has become a paper maché mask..."
On the other hand, especially as he grew older, he came positively to worship
women: "la femme représente triomphalement l'Art... je cris avec admiration:
vive la femme...vive l'art." Ensor sought out the company of women and feared
them at the same time. His complex relationship with the opposite sex and with
his own sexuality is reflected in many paintings, as when he depicts woman
as a tempting siren or an unattainable Madonna. Ensor entered close personal
relationships with only a very few women. One was Augusta Boogaerts, an
Ostend innkeeper's daughter with whom he maintained a lifelong friendship;
another was Mariette Rousseau, the wife of his friend, the physicist Ernest
Rousseau. He admired Mariette from a distance, and she apparently wished
no more.

As a boy Ensor was not a good student, showing talent only for drawing and
painting. His father recognized his son's gifts and arranged for him to begin
lessons, at age eleven, with two local artists. One of them, Edouard Dubar
(1803–1879), was a well-known Ostend caricaturist. Five years later, when the
boy was sixteen, his father sent Ensor to the Ostend Academy, where the curricu-
lum included life studies. Small-format paintings ensued, studies of the natural
scene in the environsof town, landscapes of dunes and beaches (*View Over
the Flemish Flats*, p. 8, *Bathing Hut*, p. 11). These were painted on pieces of
pinkish cardboard, packing material from his mother's shop. Even though they
may still seem a bit awkward, these works already reveal an extraordinary sensi-
tivity to the effects of light and an ability to render them, as well as great skill
in depicting the Flemish countryside and seaside in a way that brings out their
unique characteristic traits.

Portrait of the Artist's Father, 1881
Oil on canvas, 100 x 80 cm
Brussels, Musées royaux des Beaux-Arts de
Belgique

Thanks to its subtle color harmony this portrait
of the artist's father reading conveys a mood of
relaxation and tranquillity. Yet it also suggests the
loneliness of the cultivated man, who was social-
ly isolated in Ostend and, due to his idleness,
was treated with contempt by the women of the
family.

Ensor with Ernest Rousseau, Jr., in the Dunes at
Ostend, 1892

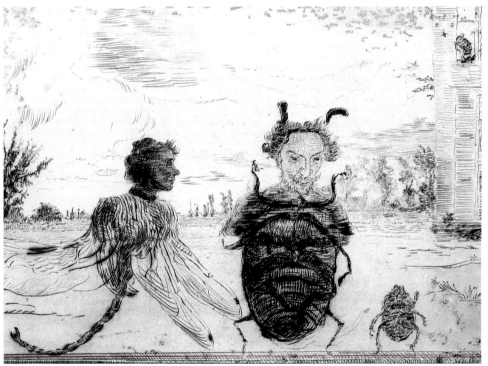

Strange Insects, 1888
Drypoint on Japan, 11.4 x 15.4 cm
Slijpe (Belgium), James Ensor Archief,
P. Florizoone

Ensor's friendship with Mariette Rousseau, the
wife of his Brussels mentor Ernest Rousseau,
was tinged with unrequited desire. Inspired by
Heinrich Heine's poem "Die Launen der Verlieb-
ten" (Lovers' Fancies), he depicted her here as a
dragonfly and himself as a beetle:

"The beetle sat on a fence, sadly;
Having fallen in love with a fly.

Thou art, oh Fly of my heart,
The spouse I have set apart.

Marry me, do not be cold!
My belly is made of purest gold..."

The next year, at age seventeen, Ensor enrolled at the Académie Royale des
Beaux-Arts in Brussels. He took courses in drawing from antique casts and in
painting from nature. But the dry conventional instruction piqued and discou-
raged him. "I was forced," Ensor later wrote, "to paint from a colorless plaster
cast a bust of Octavian, the grandest of all Caesars. This plaster got my goat.
I painted it a pink, chicken-meat color and the hair reddish yellow, to the amuse-
ment of the students – an amusement that brought furrowed brows and harrass-
ment in its wake. Finally the irate professors capitulated in face of my audacity.
From that point on they let me go my own way, and I was able to paint from live
models."

The upshot of his on the whole unsatisfactory schooling was that Ensor left
the academy after only two years. Though he maintained he had learned nothing
in this "establishment for the near-blind," he had found friends, the artists Willy

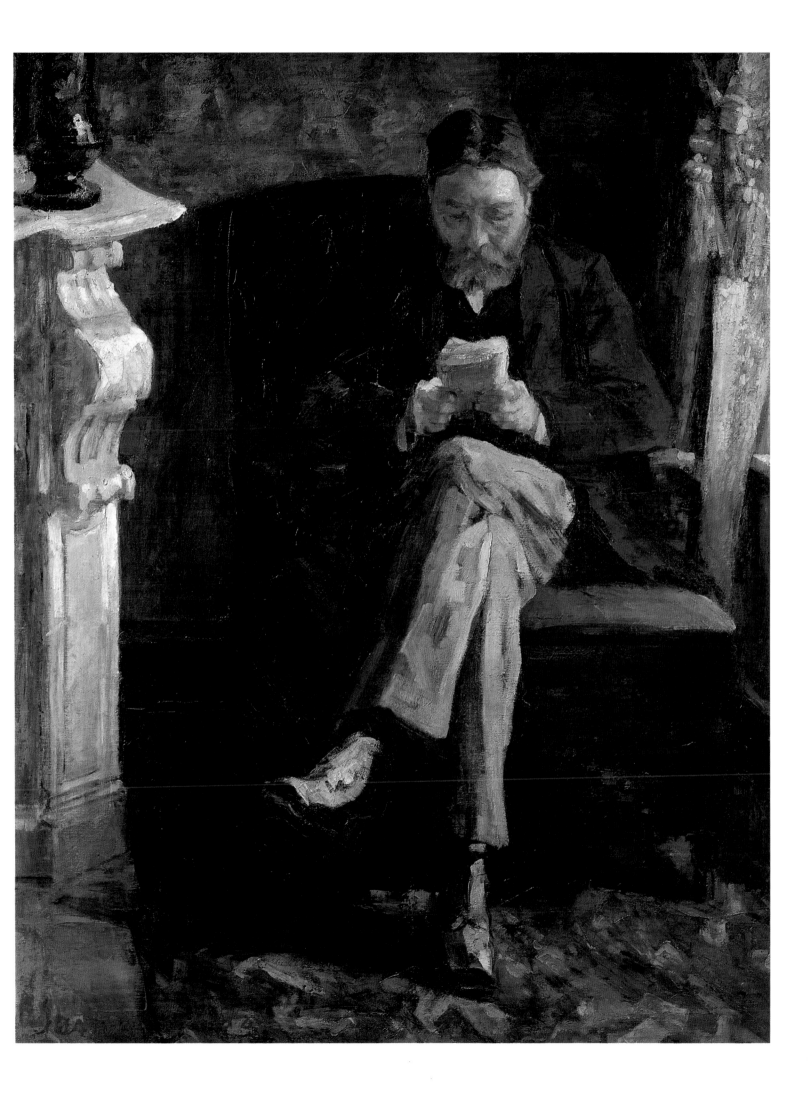

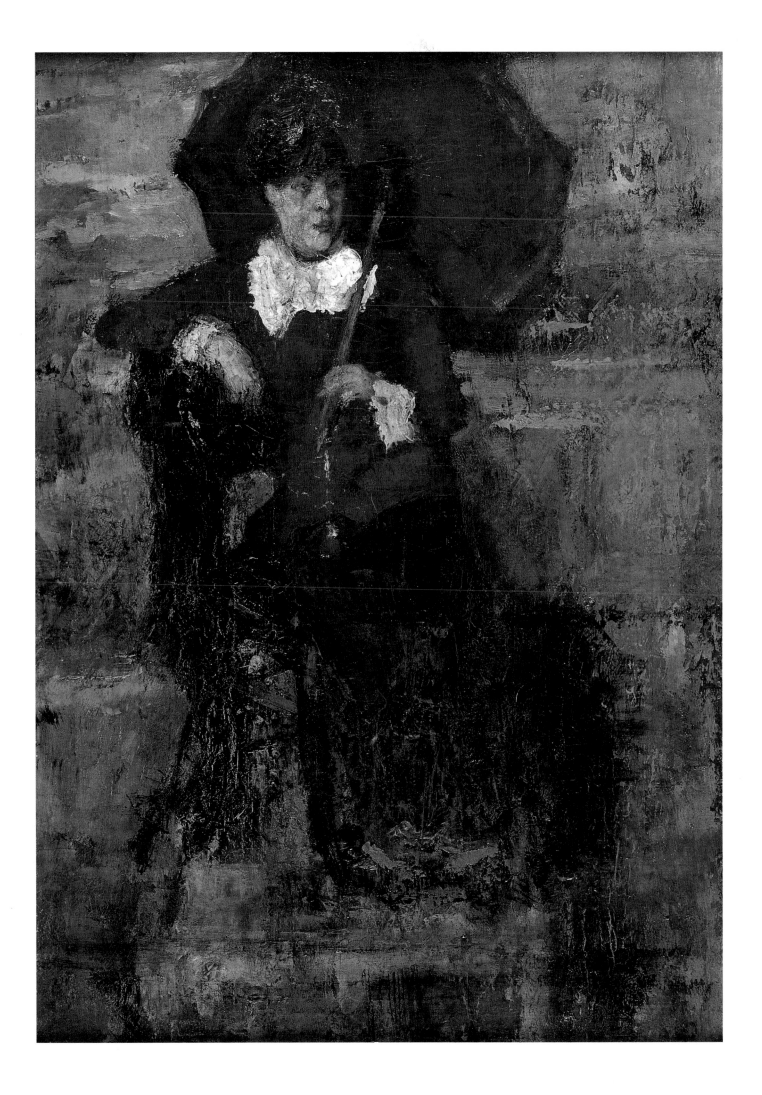

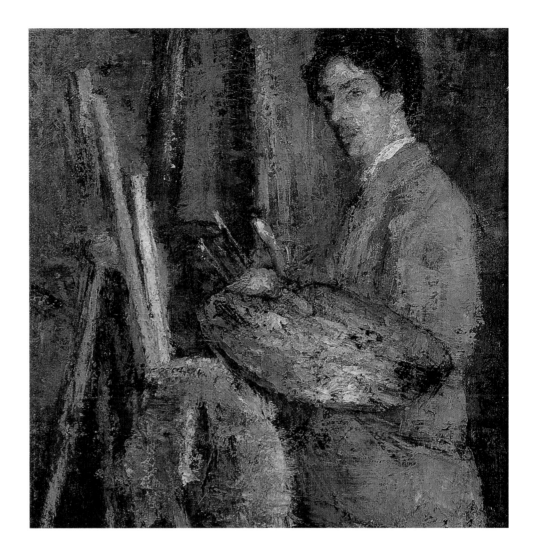

Portrait of the Artist at his Easel (detail), 1879
Oil on canvas, 40 x 33 cm
Private collection

This first self-portait, done at age nineteen, evinces heavy layers of paint in subdued hues, applied with a palette knife. Ensor's reserved, skeptical gaze suggests an academy graduate who is still in search of his artistic identity.

PAGE 14:
The Lady with the Red Parasol, 1880
Oil on canvas, 51 x 37 cm
Antwerp, Koninklijk Museum voor Schone Kunsten

Orienting himself on an Impressionist motif, Ensor depicts his sister Mitche as an elegantly dressed lady, seated in an outdoor setting. The intense red of parasol and jacket forms an effective contrast to the indeterminate background rendered in subtle gradations of brown and gray.

Finch and Fernand Khnopff, and also the universally talented Théo Hannon, who would distinguish himself equally as painter, composer, and author. After leaving the academy Ensor continued to return frequently to the capital, where he and his friends sought entertainment in night-long odysseys through the literary cabarets and bars.

Three years later, in 1883, Ensor would join forces with Finch, Khnopff and others to form an avant-garde group called "Les XX" or "Les Vingt" (The Twenty). It was through Hannon that he made the acquaintance of Ernest Rousseau. A physicist on the faculty of the Université Libre de Bruxelles, Rousseau was a radical critic of Belgian society who sympathized with anarchist ideas. He and his nineteen-year-younger wife Mariette, Hannon's sister, kept an open house. In its informal atmosphere gathered the progressive minds of Brussels, liberal, cosmopolitan thinkers who debated current events or key issues of the era such as the relationship of Church and State, or revolutionary new scientific discoveries.

In this heady environment Ensor visibly came into his own. It was such a sharp contrast to his constricted Ostend household, where daily life seemed often to consist of little more than squabbling and discontent. The spirit of the Rousseau house had a profound influence on Ensor's thinking. His obstinacy, his critical attitude, and his "anarchistic being" all found ample nourishment there. And in Ernest Rousseau, Jr., the family's son, he found a partner who shared his enjoyment of boisterous games and bizarre costumes and disguises. His friend's mother Mariette Rousseau, the daughter of a respected botanist, instructed their young guest in the use of the microscope and, as mentioned, came to be a life-long friend. Ensor would portray Mariette in numerous paintings, whether in the guise of a dragonfly (*Strange Insects*, p.12), as arbitrator (*Ensor and General*

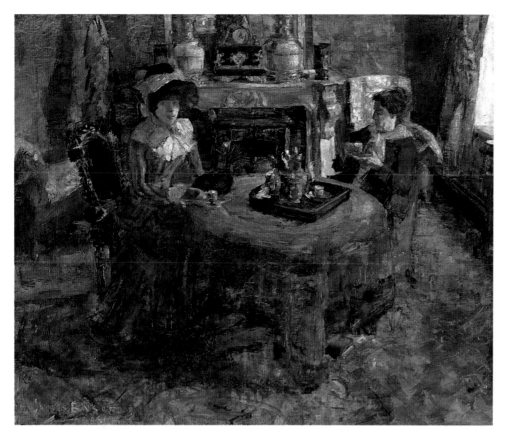

Afternoon in Ostend, 1881
Oil on canvas, 108 x 133 cm
Antwerp, Koninklijk Museum voor Schone
Kunsten

This canvas is one of a series of depictions of
typical middle-class interiors from Ensor's
"dark" period, in which the boredom and mon-
otony of his family milieu are – perhaps purposely
– evoked.

Leman Discussing Painting, p. 75), or as a friend observed at the beach (*The Baths at Ostend*).

His years at the Brussels Academy were the only extended period Ensor ever spent outside his birthplace, Ostend. All the more eagerly did he absorb the multifarious stimuli of the big city. Literary and intellectual impulses proved especially crucial to the development of his art. Ensor immersed himself in Romantic literature and waxed enthusiastic over the fantastic tales of Edgar Allen Poe. He made numerous copies, or better, creative paraphrases in pencil or etching needle of etchings by famous masters reproduced in art journals (including Rembrandt, Dürer, Goya, Daumier, Turner, Callot). There also emerged portraits of his friends and members of his family, as well as three self-portraits.

Returning to Ostend, Ensor installed a studio in the attic of his mother's souvenir shop, which overlooked the broad Flanders plain, the roofs of Ostend, and Vlaanderenstraat. In this mansard, from whose windows he could observe the sea in continually changing light, Ensor painted his most significant oils, until the year 1900.

The motifs of the Impressionists, who had had their first, vituperously criti-cized exhibition in Paris in 1874, found echoes in Ensor's *The Lady with the Red Parasol* (p. 14) and *The Cab* (p. 22) of 1880. Elegant ladies with sunlight shim-mering through parasols, busy streets seen from a bird's-eye view, and rows of buildings casting colored shadows were favorite subjects of the "plein air" paint-ers around Monet, Renoir, and Degas. Yet when Ensor addressed these themes, it was hardly with an eye to the form-dissolving properties of light and shadow. In fact, the joyful, light-flooded pictures of the French Impressionists did not espe-cially interest him. "The researches of the pointillists leave me quite cold," he wrote to Jules Dujardin (letter of October 6, 1899). Ensor worked with light with an eye to giving expression to his own personal moods, and through illumination he was able to evoke a great range of sensations, from mild melancholy to hope-less despair or well-nigh demoniacal aggressiveness. Ensor was intrigued by the possibilities of creating diverse effects through various means of depiction, of

The Bourgeois Salon, 1881
Oil on canvas, 133 x 109 cm
Antwerp, Koninklijk Museum voor Schone
Kunsten

Ensor's mother and sister appear veritably
engulfed by the elaborate furnishings of their
sitting-room. Impressionist brushwork leaves
contours blurred, and things and figures appear
immersed in a continuous flux.

The Somber Lady (The Lady in Black), 1881
Oil on canvas, 100 x 80 cm
Brussels, Musées royaux des Beaux-Arts de
Belgique

Daring combinations of colors lend this work a
tense, almost dramatic atmosphere. In this case,
too, the sitter was Ensor's sister, Mitche.

virtually recreating things or alienating them in unprecedented ways. "Light distorts contour. In this I saw an enormous realm which I could explore, a new way of seeing which I could depict." And as he explained in another place, "Because I have always grasped the importance of light and the lines influenced by it. This personal vision, I believe, has carried me into higher regions. I have unjustifiably been counted among those who favor light hues, the plein-air painters and Impressionists. Before me, no one has understood the forms of light and the deformations it exerts on line" (Ensor to Dujardin, appendix to a letter of October 6, 1899).

A "deforming" illumination of this kind is already found in the interiors painted in the early 1880s. In what were termed "salon paintings" Ensor depicted his models, usually family members, in a domestic milieu suffused by an atmosphere of gloom, almost oppressiveness. This is clearly evident in *Afternoon at Ostend* (p. 16), where two women (the artist's mother and sister) sit bored and stiff at a coffee table. The treatment of the darkened room with its heavy furniture and dark carpets perfectly captures the ennui of a provincial afternoon. The sister appears to gaze without interest at the observer; the mother seems uncomfortably squeezed between armchair and table. The daylight filtering dimly through thick white curtains falls on fireplace, table, and floor, conjuring up light-gray flecks and scattered dabs of red and green which cause the contours of objects to blur. Though Ensor's interiors – like all of his works – are realistic, the tendency of the illumination and stippled paint application to dissolve objects lends them a quite unique and occasionally ghostly character. The

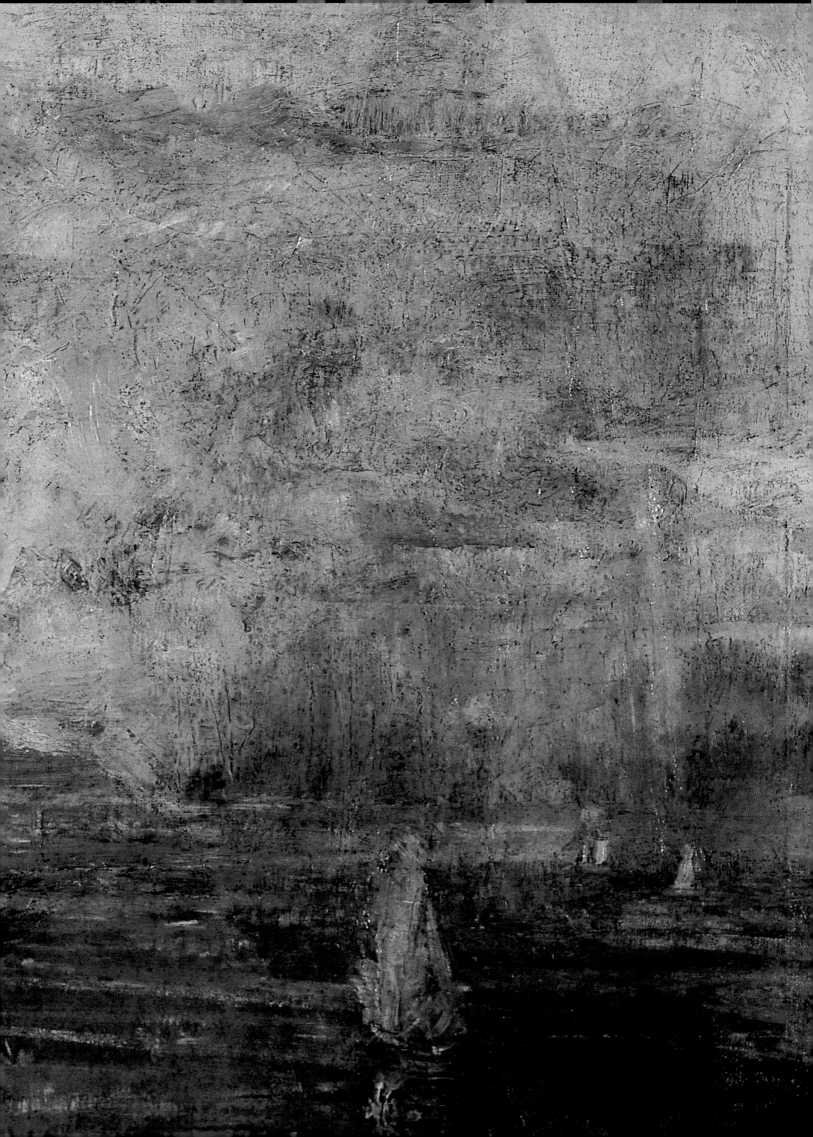

Claude Monet
Sea Study, 1881
Oil on canvas, 50 x 73 cm
Private collection

Based on direct observation of nature, Monet captures the fleeting effects of light on the sea in light-suffused colors applied with rhythmical slashes of the brush. In contrast, Ensor in similar subjects applied the paint in thin patches placed next to and over one another, as if to detach himself from natural appearances and dispense with the effects of space and time.

scene takes on a constricted, chilling atmosphere, as if spirited into some twilight zone between reality and dream by the artist's negation of the borderline between the visible and the imagined. Later Ensor would lend concrete, if often surreal traits to the secret that lurks invisibly beneath quotidian appearances: the grimacing faces, masks, and skeletons that placed their inimitable mark upon his imagery.

In his seascapes too, despite their lighter and more brilliant colors, forms disintegrate, contours dissolve in scintillating light. For Ensor, who spent nearly his entire life in its immediate proximity, the sea meant a great deal. As he once noted, "I was guided by a secret instinct, a feeling for the atmosphere of the seacoast, which I had imbibed with the breeze, inhaled with the pearly mists, soaked up in the waves, heard in the wind".

And in a passage written in the 1920s and redolent of the metaphorical, playfully ironic yet pathos-filled style of the day, he exclaimed, "Beneficent sea, revered mother, I offer humble praise with a fresh bouquet to your hundred faces, your gleaming skin, your dimples, your rosy lingerie, your diamond crown, your sapphire coverlet, your blessings, your blisses, your unfathomable charms." The ocean not only presented a continually changing play of light; it also harbored unknown and frightening mysteries.

In Ensor's marine pieces the borderlines between water, land, air seem expunged. The brushwork is dry, rough; the paint is applied with strokes of a flat brush in continually changing directions, leaving the texture of the heavy canvas showing through in places. Even though Ensor's *After the Storm* (p. 20) may recall Impressionism, a comparison with Monet's *Stormy Sea* of 1881 makes clear the characteristic differences between his approach and that of his Impressionist contemporaries. Where Monet uses slashing strokes to evoke water in motion, Ensor builds up thin layers of paint, over and next to one another. Where the Impressionists attempt to capture a certain point in time, Ensor dispenses with both time and space, projects visions of color and light. These would appear to be highly influenced by the works of William Turner, who already in the 1830s had left objectivity behind. Still, it remains an open question whether Ensor knew the English artist's pictures as early as 1880, because it is highly doubtful that Ensor visited London, where Turner's pictures

Boats on the Beach, 1888
Etching on old, ribbed paper,
17.6 x 23.7 cm
Private collection

PAGE 20:
After the Storm (detail), 1880
Oil on canvas, 52.5 x 62.5 cm
Ostend, Museum voor Schone Kunsten

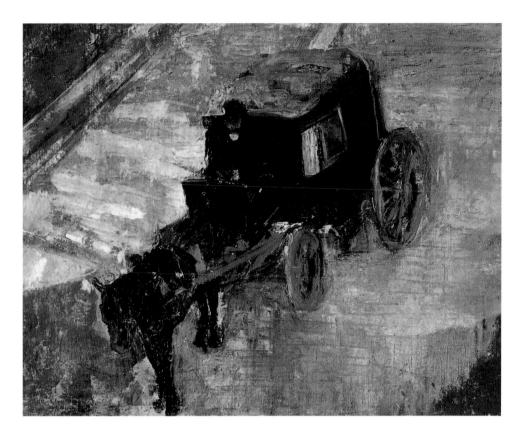

The Cab, 1880/1882
Oil on canvas, 41.5 x 54 cm
Private collection

Using a limited range of colors applied with
broad brushstrokes, Ensor renders an everyday
scene in diagonally arranged areas of light and
dark that evoke dynamic movement.

were on display in the National Gallery, before 1887 (with Guillaume Vogels)
and 1892. Very probably, however, he had seen Turner's works reproduced in art
journals and books; his father's extensive library included numerous issues of *Le
magasin pittoresque, La gazette des Beaux-Arts, L'Art, The Studio*, as well as a
copy of *La peinture anglaise*.

Some of the still lifes of the 1880s likewise are suffused with a mysterious,
provocative mood on account of their surprising composition, unusual palette,
and idiosyncratic choice of motifs (see for instance *Still Life with Duck*, p. 25).
Regarding this last element, Ensor at times recurs to the tradition of Flemish still
life in the seventeenth century. He depicts jugs and fruit, poultry and marine
creatures in what appear to be quite random combinations and juxtapositions.
Yet whereas the traditional pictures were intended to convey moral precepts or
agreed symbolic meanings, Ensor's still lifes emphasize the grotesque aspect of
things and again and again heighten them to the point of the surreal. A bird, for
instance, becomes a macabre duck's cadaver, or a ray turns into a little monster
with human features (and in combination with the basket lying next to it, per-
haps takes on an erotic connotation). In contrast to the sense of freedom evoked
by his seascapes, Ensor's still lifes – similar to his interiors – tend to reflect the
constrictions he found in bourgeois society and in his own family. Initially the
artist concentrated on his immediate surroundings, which he treated with a
clear, if at times scurrilously accented, realistic approach, reminiscent of Cour-
bet. In the course of the years, however, the still lifes became more and more the
vehicle for Ensor's subjective vision and personal style. At his best, Ensor is a
virtuoso at rendering the different consistencies and textures of things, be it the
hard cool surface of a glass bottle, the wrinkled, flabby skin of a dead duck, the
dry brittleness of a pile of hay, the gelatinous flesh of a ray. His differentiated
and unconventionally accentuated depiction of objects enables Ensor to evoke
the insentient world in a way that transforms it, as it were, into a dramatic, emo-
tion-charged scene. In other words, he goes far beyond mere naturalistic depic-
tion, and it is this that lends his still lifes their bizarre, alien, and expressive
effect.

View of Rue de Flandre, postcard, c. 1900

"From 1860 I lived in various houses in Ostend,
the most important being a large house with a
cut-off corner at the intersection of Rampe de
Flandre and Boulevard van Iseghem. My atelier
there has five windows... From the big window at
the height of the balustrade one overlooks a large
part of the town, and a few views over the land-
scape supplement the wonderful panorama at
will. From this vantage point I painted the *Rue de
Flandre*, 1881, *The Rooftops* in 1884..., *Rue de
Flandre in the Snow*, 1880, *Music in the Rue de
Flandre*, etc."

PAGE 23:
Rue de Flandre in the Snow, 1881
Oil on canvas, 41.5 x 54 cm
Vaduz, Fondation Socindec

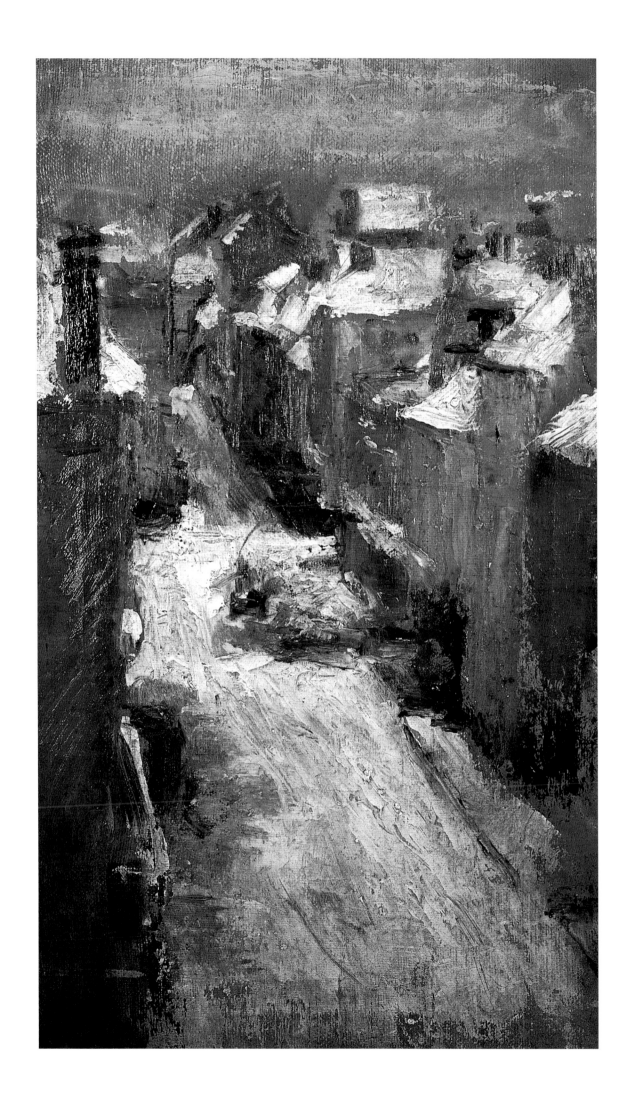

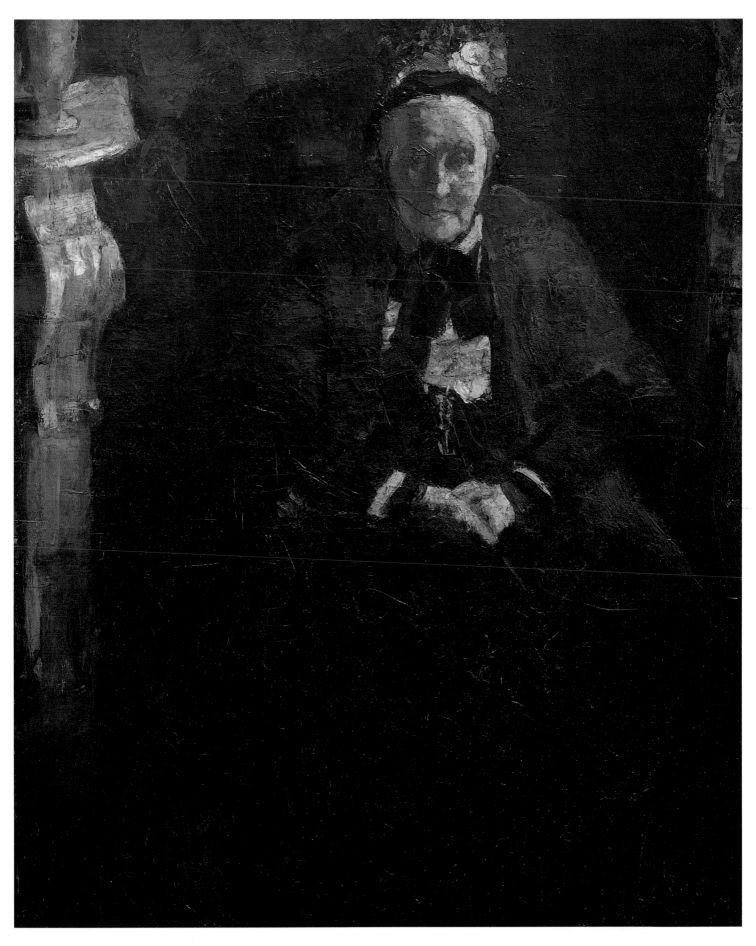

Woman with Blue Shawl, 1881
Oil on canvas, 74 x 59 cm. Antwerp, Koninklijk
Museum voor Schone Kunsten

The sitter here is Ensor's maternal grandmother,
who lived with the family. The strictness of her
personality is emphasized by white accents of
light arranged along the vertical, and the intense
blue of the shawl effectively sets off the figure
from the dark environment.

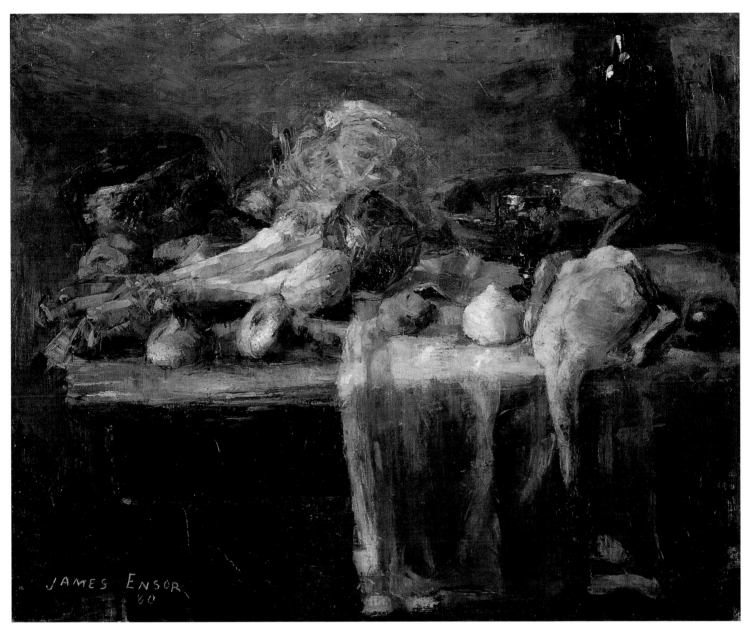

Still Life with Duck, 1880
Oil on canvas, 82 x 102 cm
Tournai, Musée des Beaux-Arts

"Certainly there are also lovely, noble seascapes and landscapes from his hand in which he shows himself from his contemplative side... but we should not turn away from his canvases without stating that he is also an outstanding painter of still lifes. Here he proves himself to be in the class of a Louis Dubois. The same delicious sensuousness, the same exquisite, sumptuous colors, the same lascivious love of superb mixtures of the color palette. But he distinguishes himself through his more sensitive, more musical treatment of light. And everything is alive, a wild life of color and the quotidian. The things possess nerve cords to the light rays... What appeals beyond this in his still lifes is the casualness of the rendering, very artistic, very spontaneous, personal and liberated from all traditional rules." (Eugène Demolder)

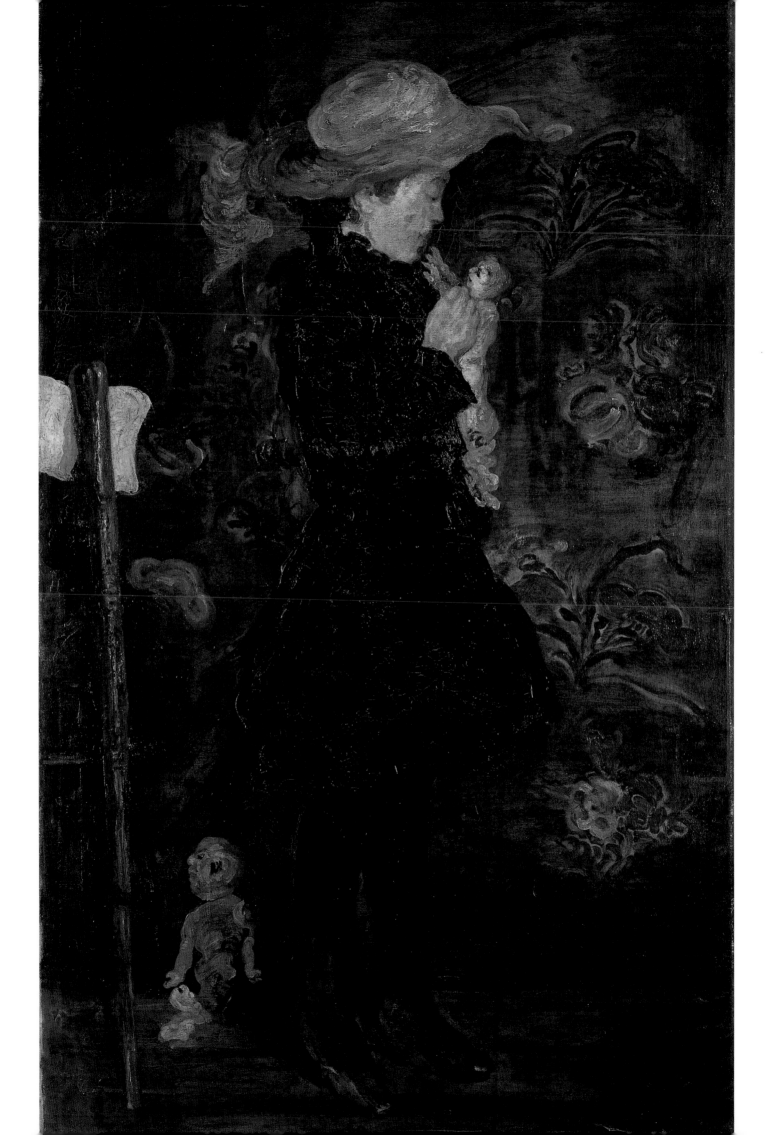

Between Realism and Imagination

In 1880 in Brussels, Octave Maus, attorney at law, journalist, and art critic, together with Edmond Picard, Victor Arnould and Eugène Robert, founded a weekly magazine of art called *L'Art Moderne*. It was devoted to all new trends in music, theater, literature, visual art, and the arts and crafts – in a word, to an independent, "free" art no longer beholden to academic traditions. Ensor regularly read this publication. In the year 1883, at the behest of Octave Maus among others, *L'Art Moderne* reported the establishment of an association of artists called "Les Vingt," a group of progressive Belgian painters and sculptors who set out to organize joint exhibitions to which they intended to invite innovative artists from the neighboring countries. Although the group had no clearly defined program, its members were united in the conviction that the highest possible degree of progressiveness constituted the decisive criterion in art. However, as might be expected, the members' opinions differed greatly as to what could be considered "progressive" and by what means "progressiveness" could be achieved.

Members of the group included Fernand Khnopff, subsequently to become one of the most significant Symbolists; Théo van Rysselberghe, who adopted Pointillism from Seurat; and Willy Finch, an Impressionist who subsequently, like Henry van de Velde, turned to decorative art. Ensor joined "Les Vingt" and regularly submitted works to their exhibitions. Here the so often misunderstood artist found a forum of like minds, at least for a brief period. The support he received explains why Ensor fought vehemently, if vainly, for the continuation of "Les Vingt" when Maus decided to dissolve the group after ten years of existence.

Thanks to "Les Vingt," Brussels advanced in the decade before the turn of the century to become a key center of the Western European vanguard, and the group took on increasing significance as a focus of innovative styles, including Symbolism and Art Nouveau. Among the artists who exhibited with "Les Vingt" were many major names of the period: Monet, Seurat, Toulouse-Lautrec, Redon, Renoir, Cézanne. At one of their shows van Gogh sold the only picture he would ever sell during his lifetime. Yet the founding members of "Les Vingt" were not concerned with exhibiting alone; they envisaged furthering cultural education in the widest sense of the term. Octave Maus, himself an enthusiastic pianist, organized concerts (at which, among others, Tchaikovsky and Rimsky-Korsakov were performed) and lecture series. The long list of authors invited to read from their works included such then still quite unknown poets as Stéphane Mallarmé, Catulle Mendès, and Paul Verlaine.

Although Ensor for the most part treated traditional subject matter in the early 1880s – for example portraits of friends and family members, views of Ostend or seascapes – his works nonetheless increasingly showed a change of approach to such themes. Gradually he developed that highly individual point of view which would later find its culmination in the mask paintings, and which now offered him a way to escape the confines of his domestic situation. In the grotesque and

Self-Portrait, 1885
Pencil on paper, 22 x 17 cm
Private collection

Ensor depicted his own features again and again in the course of his career. Here he represents himself as a draftsman working with the utmost concentration, if with a skeptical look in his eye.

PAGE 26:
Child with Doll, 1884
Oil on canvas, 149 x 91 cm
Cologne, Wallraf-Richartz-Museum

A realistic figure painting in primarily dark, complementary hues. The agitated patterns on the wallpaper in the background have a strange, almost threatening aspect.

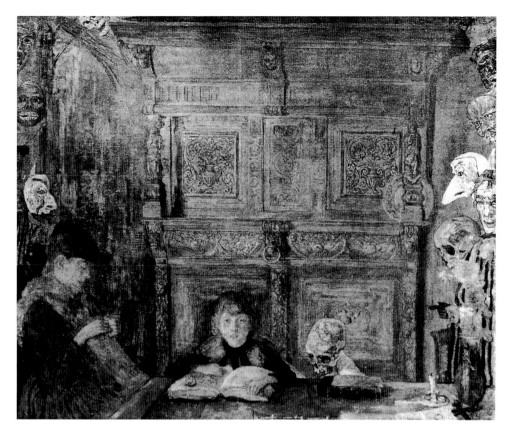

PAGE 29:
The Oyster-Eater, 1882
Oil on canvas, 207 x 150 cm
Antwerp, Koninklijk Museum voor Schone
Kunsten

The *Oyster-Eater* was rejected by the Antwerp
Salon in 1882, and the following year the art
society "L'Essor" likewise refused it on account
of its unconventional composition. It was exhib-
ited for the first time in 1886, at the "Les Vingt"
Salon.

The Haunted Dresser, 1885–c. 1890
Oil on canvas, 89 x 103 cm
(destroyed in the Second World War)

About five years after finishing this interior,
Ensor added masks and skulls, thus transforming
what had been an innocent genre painting into a
ghostly scene.

the theatrical, in caricature and satire, Ensor discovered means of expression
suited to his temperament and inmost inclinations. It was precisely his develop-
ment of a vehicle to convey his radical, sarcastic, irreverent view of the world
around him which enabled him to continue leading what to all outside appear-
ances was an entirely unspectacular middle-class life, without extensive travels,
without public dealings with his artist colleagues. In his paintings Ensor tore the
veil of pretensions from banal everyday life and set against them his own, phan-
tasmagorical inventions.

The painting *Child with Doll* (p. 26), 1884, with its primarily somber tones,
provides an especially good illustration of the gradual changeover from a basic-
ally realistic approach to one in which the strange and fantastic play a key role.
What initially appears to be a wall with a floral-patterned wallpaper turns out on
closer scrutiny to represent a whirl of blossoms and leaves surrounding the fig-
ure of a young girl holding a doll. Behind the girl's figure the shapes blur and
blend, and are seemingly attracted by some magnetic force toward the floor,
where a doll with human facial features and oddly distorted limbs crouches.
This deformed creature, gazing to the left out of the picture, is extremely dis-
quieting and eerie in effect. It evokes a vague sense of doom, something by
nature diffuse and thus alienating to the viewer; a motif that on first glance
seems so harmless and familiar is suddenly rent asunder to reveal the ominous
gulfs beneath a world we take for granted.

Ensor proves himself a subtle colorist in this picture. The complementary col-
ors of the background are repeated, in subdued gradations, in the floor, and in
lighter gradations in the doll on the left. The illumination, harmonious and soft,
mitigates the heaviness of the dark figure of the girl. Even though this work of
1884, owing to its subdued palette, may recall the dark pictures of the early
phase, it is more strongly indicative of the reorientation towards a lighter palette
that had announced itself the year before. *The Oyster-Eater* (p. 29) is a typical
work of this transitional period, by the end of which Ensor had begun to place a
greater emphasis on the effects of light. Though the subject cannot be conside-
red new – Manet, for one, had already treated it – Ensor's approach is quite

Stove and Figures, c. 1884
Chalk and colored pencils on paper,
Slijpe (Belgium), James Ensor Archief,
P. Florizoone

Nude at a Balustrade (detail), 1886/88
Pencil and charcoal on paper, 22.5 x 17 cm
Private collection

As far as we know, Ensor never drew or painted from live nude models, as his mother was strictly opposed to it. In this reworked drawing he amalgamates his enjoyment of mystification with his shyness of women and his erotic wish-dreams.

The Rower, 1883
Oil on canvas, 79 x 99 cm
Antwerp, Koninklijk Museum voor Schone Kunsten

PAGE 31 ABOVE:
The Drunkards, 1883
Oil on canvas, 115 x 165 cm
Brussells, Collection Crédit Communal – Dexia

"With his disgusting drunkards from the common people, which we have already roundly rejected more than once, M. Ensor has nevertheless drawn attention to himself. Why?... Suddenly he has achieved lighting effects which, after initially confusing one, take on an amazing reality. This is not the light we are accustomed to seeing in paintings; it is a different light, and possibly it is very much truer than the other... M. Ensor is only following a path already open. And I believe that out of these more or less formless attempts, something in the nature of the art of the future will soon emerge: young art, if you will..." (review in a Brussels daily paper, 1884).

unprecedented and original. The sumptuous, sensuous arrangement, the suggestive coloration, and an illumination that lends the whole an air of unreality, point up Ensor's distance from the realistic manner of a Courbet or the painting-in-light of the French Impressionists.

In Ensor's interiors of the 1880s the mood evoked through light and color increasingly came to play a central role. In this regard, it is revealing to compare two pictures with similar motifs, painted four years apart, *The Lady in Distress* (p. 32), 1882, and *Children Washing* (p. 33), 1886. Both canvases depict a room in the house of the artist's parents. In the 1882 picture, heavy curtains screen the sunlight; the outside world seems excluded, time appears to stand still. And yet the painting is by no means as dark in pervading hue as Ensor's interiors of just the previous year. Rather, the room appears plunged in a diffuse light shimmering with color, an as it were imaginary light which lends a sense of drama to the languorous, leaden atmosphere of the scene. This light alienates objects such as the loops of material holding the curtains, and suddenly they metamorphose into strange birds perched on the edge of the bed, seemingly watching or threatening the supine woman.

Even more strongly estranged by lighting effects is the spatial situation in *Children Washing*. The bright golden-yellow illumination, a product of the artist's imagination, robs the things in the picture of all mass and gravity. It conveys a mood of mystery and enchantment. "The atmosphere is redolent of ambergris, fragile, gentle, resonant," said Emile Verhaeren about this picture.

Just as in the seascapes, in this case too William Turner's works of the 1830s and 1840s, in which objects inundated by a diffuse atmosphere become mere webs of color, may well have provided a model to Ensor. Yet whereas Turner virtually dissolves the things in his pictures in color and light, Ensor's depiction remains beholden to solidly graspable reality. He sublimates realistically rendered interiors by means of poetic, imaginary elements into a kind of "magic realism" of great emotional compellingness. Looking at *Children Washing* one has the odd sensation that the piece of furniture on the left is making faces at us, and even more obviously than in *The Lady in Distress*, a curtain loop proves to be a kobold crouching on the chest of drawers.

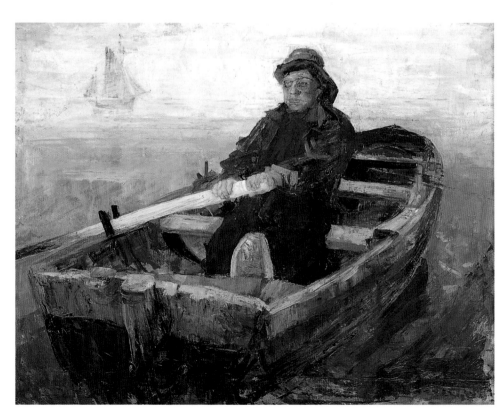

Gradually but continually Ensor turned away from a realistic, objective view of the world and towards a realm of the imaginary and fantastic. Obsessions and anxieties apparently played just as great a role in this development as Ensor's penchant for mystifying things and events. As his art developed, he increasingly blended reality with dream, lent everyday useful objects threatening and demoniacal traits, enlivened his scenes with grotesque figures, grimacing faces, masks, uncanny apparitions.

Many art historians who deal with Ensor have interpreted this as reflecting the artist's insecure, mistrustful personality. A key piece of evidence in their case is a childhood experience Ensor himself described as crucial, and to which he repeatedly referred in his letters and writings. It is not so much the event itself that seems amazing as the way Ensor continued to recall it, decade after decade, in almost the same words: "One night, as I lay in my room with the light on and windows wide open on the ocean, a big sea bird, attracted by the light, came swooping down in front of me and crashed to the floor, hitting my cradle as it fell. An unforgettable impression, insane, terrible. I can still see that horrible apparition and feel the impact of that strange black bird."

The mask motif, ever more central to Ensor as the 1880s progressed, occurs for the first time in *The Scandalized Masks* of 1883 (p. 38). The composition shows a man in a carnival mask seated at a table with a half-empty bottle in front of him, as another masked man dressed in women's clothing and brandishing a stick enters the room from the right. The scene calls to mind a husband being caught drinking in a pub by his wife. In fact it has repeatedly been inter-

My Portrait in Sadness and Glory, 1886
Charcoal on paper, 23.5 x 17.2 cm
Private collection

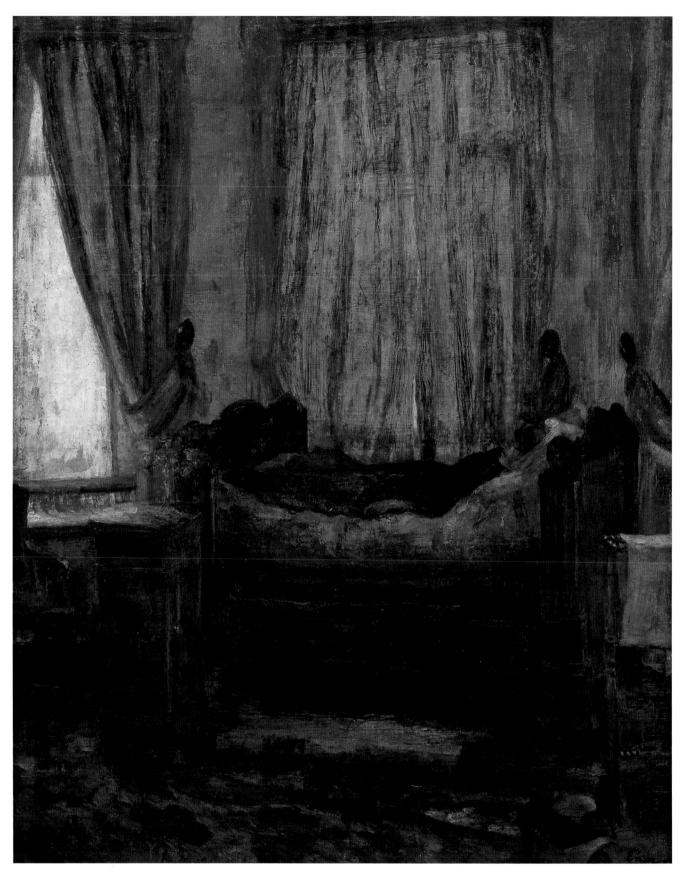

The Lady in Distress, 1882
Oil on canvas, 100.5 x 80 cm
Paris, Musée d'Orsay

The composition is suffused with a dim, diffuse
light that obscures the contours of figure and
objects. The colored shadows take on a life of
their own; the atmosphere of the interior is
strangely eerie, oppressive.

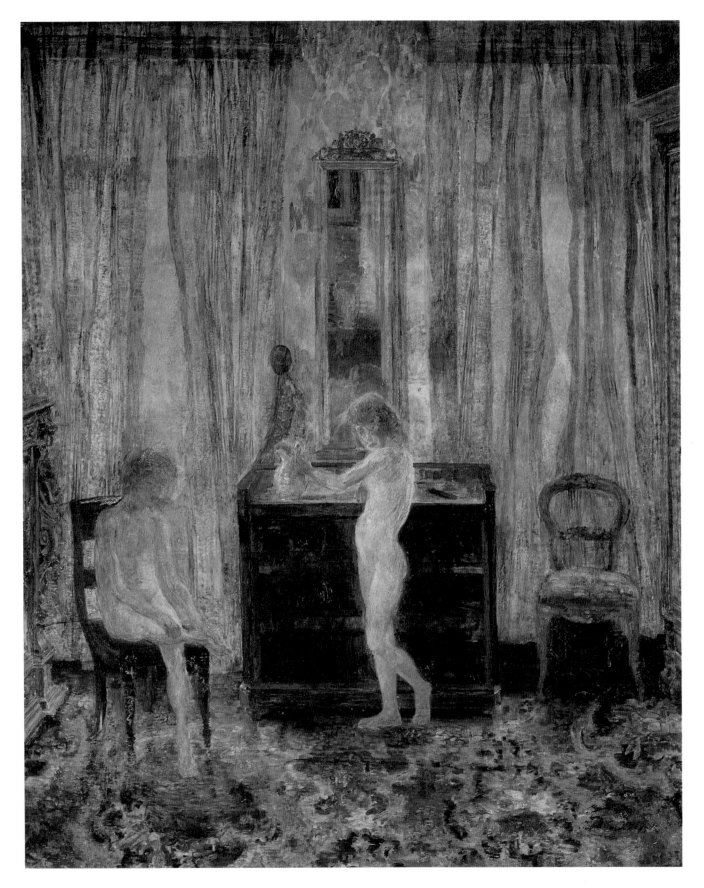

Children Washing, 1886
Oil on canvas, 135 x 100 cm
Private collection

This symbolistic composition reflects the influence of Turner, whose works Ensor first saw in illustrations in his father's library. Light partially dissolves the outlines of objects and creates an atmosphere of unreality.

preted in biographical terms as an allusion on Ensor's part to his father's alcoholism. In this case the attribute of the mask, at least as far as the seated figure is concerned, is an object that stands more or less for itself. Later Ensor would begin to merge figures and masks into organic entities, linking the two elements indissolubly, transforming face masks into mask-faces.

The canvas *Skeleton Looking at Chinoiseries* of 1885 is equally difficult to interpret with respect to its "true" content. It shows an attic room in which a figure with a skeleton's skull relaxes in an armchair, immersed in contemplation of a portfolio of Chinese prints. On the walls hang a number of other pictures, rendered in loose brushwork; the room is illuminated by daylight falling through a dormer window.

Oriental art was much appreciated by Ensor, as it was by the Impressionists and Symbolists. In his case an interest in "chinoiseries" was evidently awakened in early childhood, by his mother's souvenir and curio shop. What is more, his sister Mitche married a Chinese dealer in masks and furnishings who supplied the shop in Vlaanderenstraat with East Asian goods. However, after only a year Mitche's husband vanished from the family circle, leaving her alone with a little daughter.

What Ensor appears to express by means of the skeleton in this interior scene framed by a doorway is a provocative indifference to the visible, quotidian world, for he obviously loved depictions in which humor and horror, the familiar and the shocking were combined in a way that, probably intentionally, discomfited the complacent viewer. By the end of the 1880s the skeleton had advanced to become the dominant motif in his compositions. This circumstance has led some commentators to suppose that he "supplemented" the painting in question by adding this motif at a later date. It is true that revisions and additions are frequently found in Ensor's work (for example in *The Haunted Dresser*, p. 28 above). In most cases, however, these were changes that shifted the realistic character of a picture in the direction of the fantastic, as is clearly seen in the drawing *Stove and Figures* (p. 28).

Ensor's biographer Paul Haesaerts assumes that *Skeleton Looking at Chinoi-*

Mirror with Skeleton, 1890
Pencil on paper, 29.5 x 21.5 cm
Private collection

In this drawing death is represented as a female figure, accompanied by the maskers of a universal carnival.

Fans and Stuffs, 1885
Oil on canvas, 47.5 x 55.5 cm
Zurich, Kunsthaus Zürich

Its daring color scheme, impasto paint application, and white highlights lend this still life an extremely disquieting effect. Only the skull at the left edge suggests reality, while such passages as the pitcher composed of scintillating flecks of color seem subject to their own esoteric laws.

Skeleton Looking at Chinoiseries, c. 1910
(reprise of an earlier work, finished between
1885–1890)
Oil on canvas, 100 x 60 cm
Cologne, Wallraf-Richartz-Museum

Orientalism was highly popular among European
artists of the fin de siècle. Ensor, for his part,
was familiar with Chinese arts and crafts from
his mother's shop. By adding a death's head to
the picture at a later date he supplemented the
genre scene by a fantastic aspect, and thus pro-
duced a sarcastic visual commentary on a world
beyond normal appearances.

series represents a self-portrait and reflects a man obsessed equally by art and
death. Yet this does not seem convincing in view of the peaceful and serene
mood of the picture. What we can safely say is that here, as already in *Child
with Doll*, reality and fiction obviously interpenetrate; the artist's imagination
generates a phantasmagoria of great symbolic power. Another remarkable fea-
ture of the composition is the way Ensor handles color. He sets areas of compact
impasto paint, applied with a palette knife (chair, portfolio, lampshade) next to
passages stippled in with a brush, leaving the underlying canvas texture visible
(pictures on the wall), and covers still other areas with a thin wash (floor, flank-
ing beams and joists, ceiling). In conjunction with a light-hued and pure colora-
tion, this paint handling produces a highly unconventional but compelling over-
all impression.

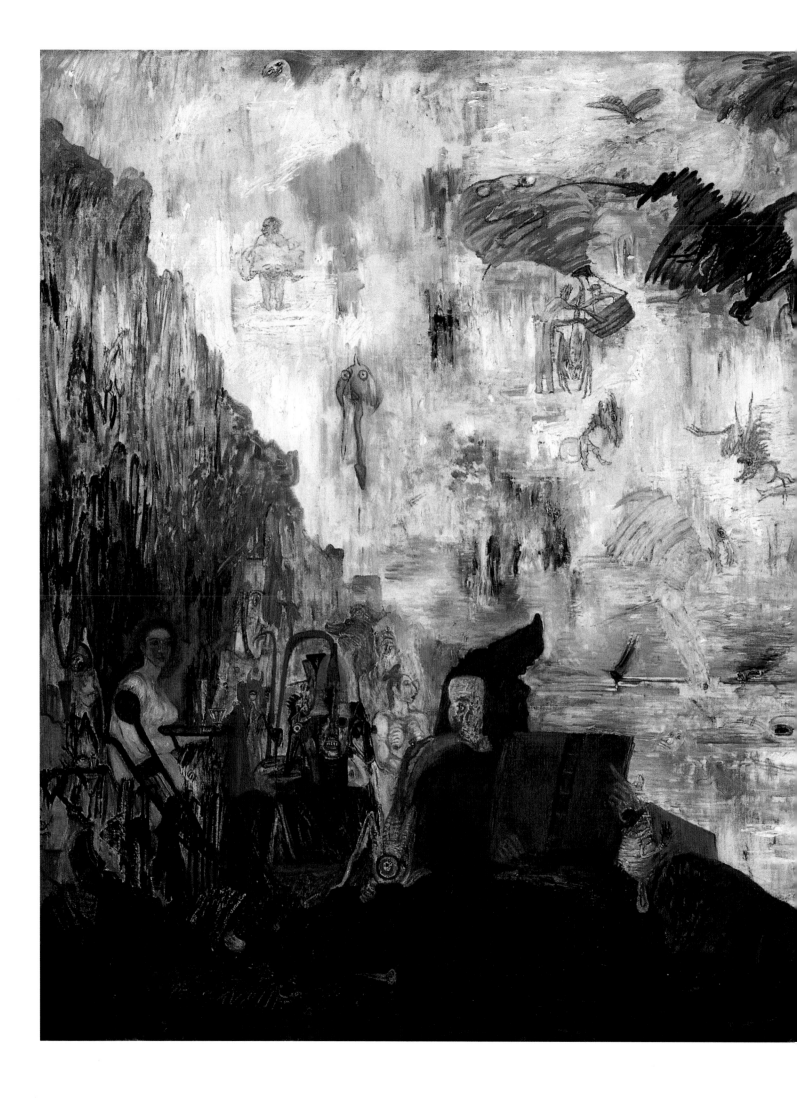

The Tribulations of St. Anthony,
1887
Oil on canvas, 118 x 167.5 cm
New York, The Museum of Modern
Art

"His brush rushes across the canvas
and whirls with an insouciance
equalled only by the audacity of his
imagination," said Alfred H. Barr,
first director of the Museum of
Modern Art, New York. In Barr's
view Ensor was, at this moment in
his career, probably the most daring
of living painters.

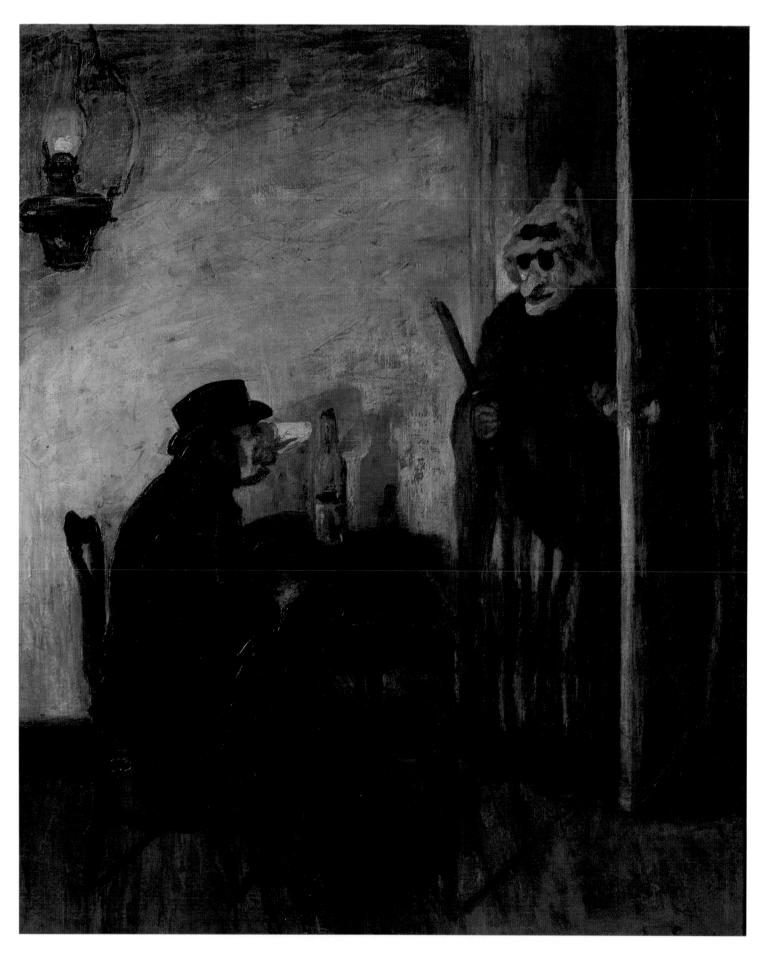

The Scandalized Masks, 1883
Oil on canvas, 135 x 112 cm
Brussels, Musées royaux des Beaux-Arts de
Belgique

This is the first instance of Ensor's employment
of the mask motif, which figures prominently in
Belgian folklore and customs. It remains an open
question whether he alluded here to his domestic

situation – his father was considered a drunkard
and was scorned by the females of the family –
or whether he meant merely to depict a carnival
scene.

Ensor was twenty-five when he painted this picture. He was living in his parents' house and had as yet absolutely no success as a painter. The "Les Vingt" group had repeatedly rejected his canvases. Though they finally, after several refusals, exhibited his *Oyster-Eater* in 1886, its daring perspective and unconventional composition drew harsh attacks from the critics. Ensor suffered terribly from this lack of recognition. He withdrew to the safe haven of his attic studio and plunged into his work.

According to many of his contemporaries, Ensor's character was dominated by irascibility and uncontrolled outbreaks. He could become unexpectedly aggressive, only to fall silent for days on end. His family tended to be unappreciative of his work, only his father showing interest and developing an understanding for his son's ambitions. His mother accused Ensor, as she accused his father, of contributing nothing to the family's income, and told him the least he could do was to paint pictures that would sell in her shop.

Ensor's frustration was vented in sudden attacks on the family piano or unexpected verbal sallies. His speeches could be very insulting and of a candidness that hurt. These unrestrained outbreaks had something bewilderingly destructive about them, that also found expression in his style of painting. About Ensor's *Tribulations of St. Anthony*, for example, Emile Verhaeren writes, "The picturesque aspect of this Christian nightmare interests him more than its terrors. And he acts as a dilettante of the impossible rather than as an avenger of vice or a master of virtue. He engenders horror elsewhere: He delineates it within himself."

A lack of appreciation, a social environment that derided the eccentric artist, an audience that rejected his paintings, wore on Ensor and provoked an attitude

Rooftops of Ostend, 1884
Oil on canvas, 157 x 209 cm
Antwerp, Koninklijk Museum voor Schone Kunsten

Ensor painted the view from his mansard window a great number of times. In the present canvas, three quarters of the area is taken up by a leaden sky with rainclouds rendered in impasto paint.

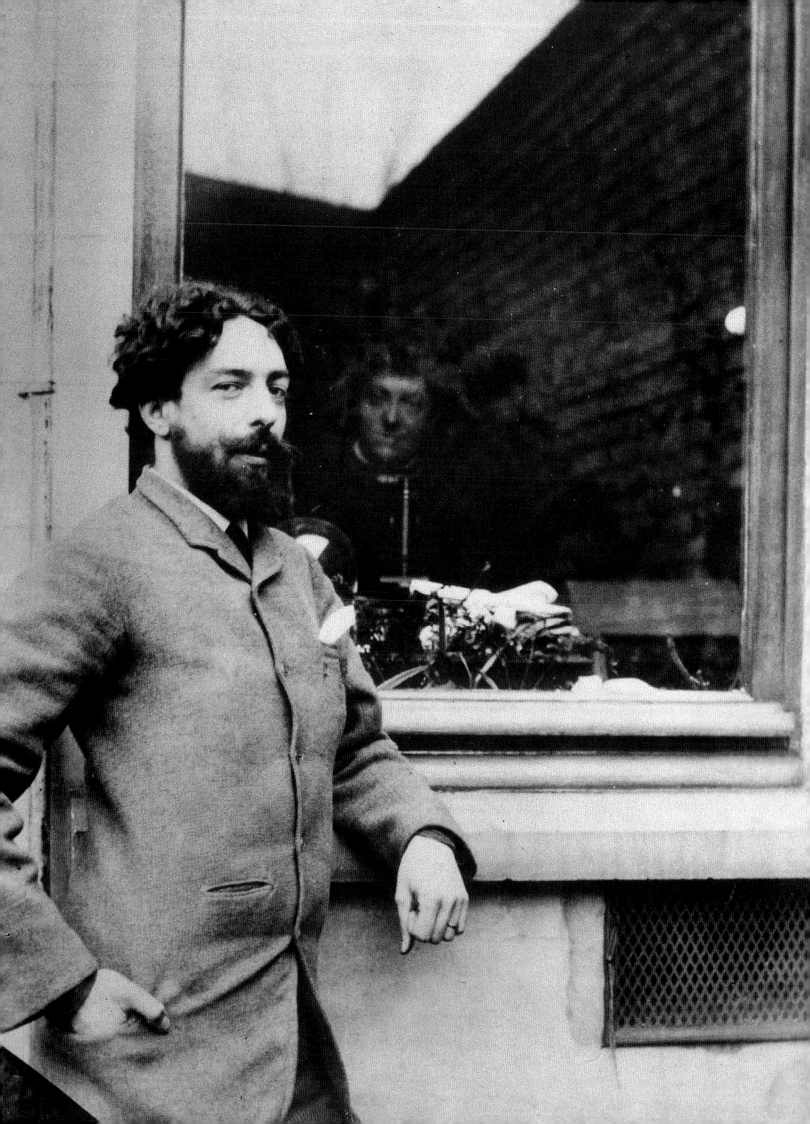

that revealed itself in sarcastic verbal attacks, aggressiveness, and depression. "The Ostenders," he wrote in a letter to his friend Pol de Mont in 1895, "an oyster public, sit tight, don't want to see the pictures. A hostile public, creeping down the sandy beach, Ostenders detest art... Last year thirty Ostenders came to see the exhibition; this year we'll reach the number of thirty-one."

Ensor thought of himself as a sort of leader among young Belgian artists, some of whom, including Finch and Vogels, indeed recognized him as such. They saw the Ostend painter as the quintessentially anti-academic artist who picked and chose among styles and motifs with complete freedom. Other members of "Les Vingt" were not so convinced, finding Ensor hypersensitive and egocentric. When at the first exhibition of "Les Vingt" he showed six paintings which were highly diverse in terms of subject and execution – including *The Lamplighter* (p. 19), *The Lady in Distress* (p. 32), *The Scandalized Masks* (p. 38), and *The Drinkers* (p. 30) – the group found this incomprehensible. The audience was equally irritated by the diversity of his subject matter and painting styles, but this did not concern Ensor overmuch. He was, however, extremely concerned by a similar reaction on the part of the critics, most of whom rejected his art outright. As Ensor's friend Eugène Demolder wrote in 1892, "He is one of those fellows who possess such great originality that the crowd cries out in disgust in front of his works, like a hungry pack of dogs howling at the moon."

The Tower of Lisseweghe, 1890
Oil on canvas, 61 x 73 cm
Vaduz, Fondation Socindec

PAGE 40:
Ensor in front of the Rousseau house in Brussels, with Mariette Rousseau visible in the window, 1888

Parade of the Masses

Biblical themes played a great part in Ensor's work from the beginning. The figure of Christ was of special significance, for in a sense Ensor identified with him. Yet it would be mistaken to assume that Ensor was a religious person; on the contrary, he considered himself an atheist. As this implies, creating religious works in the narrower sense was not one of his goals. Religious motifs merely provided Ensor with an opportunity to depict – or better, to stage – in a very interesting way the vicissitudes that so characterized his own personal life. Ensor's adaptations of religious themes, like his other motifs, are shot through with autobiographical reference.

In the drawing *The Entry of Christ into Jerusalem* (p. 44), 1885, the numerous epigrams on the flags and banners – such as "MOUVEMENT FLAMAND" (Flemish Movement), "LES XX" (The Twenty), "SALUT JESUS ROI DES JUIFS" (Welcome Jesus King of the Jews), "CHARCUTIERS DE JERUSALEM" (Butchers of Jerusalem) – express no religious convictions on Ensor's part but his personal artistic and political attitudes. The "entry" turns into a demonstration and, as such, anticipates the artist's monumental painting of 1887 – 88, *The Entry of Christ into Brussels* (p. 46/47).

This drawing is part of a series of five works collectively titled *The Halos of Christ*, or the *Sensibilities of Light*. As the wording indicates, Ensor attributed to light a metaphysical meaning that went far beyond merely technical aspects. "I have no children," he would later write, "light is my daughter: light, one and indivisible; light, the painter's bread; light, the painter's woman friend; light, queen of our senses; light, let light shine! Invigorate us, show us new paths to joy and bliss."

The large-format drawing (207 x 152 cm) has lighting effects that recall Rembrandt, the middle of the picture being inundated by a brilliant light that effaces all contours. It is an unreal, mystical illumination out of which emerges not only a motley crowd of contemporary people but the apparition of Christ himself, riding on a donkey. In the right foreground, the figure of a man rises above the mass, suggesting that here is its leader. The figure represents Emile Littré, anarchist philosopher, member of the Académie Française, and author of the *Dictionary of the French Language*, whose portrait Ensor drew from a photograph and pasted into the drawing. Littré was an agnostic and a committed advocate of the philosophy of positivism, founded by Auguste Comte. The nomination of this outspoken critic of theology to the Académie Française had met with violent resistance. As the use of Littré's portrait in the context of an image dominated by political, social, and cultural slogans indicates, Ensor was not concerned to artistically interpret the biblical event but, obviously, to comment on the contemporary situation, including his own role as an outsider in the midst of an apparently boundless human mass. There can be little doubt that the precarious situation of the mocked and reviled Christ reflects Ensor's own feelings, especially as he considered himself a reviver of Belgian art,

The Great and Glorious Entry of Christ into Jerusalem (detail), 1885
Crayon and pencil on paper, mounted on canvas, 207 x 152 cm
Ghent, Museum voor Schone Kunsten

A portrait of Emile Littré, the French anarchist philosopher, was added to the drawing by means of collage (p. 44).

PAGE 42:
Ensor with Masks, 1899
Oil on canvas, 120 x 80 cm
Private collection

Ensor seems almost overwhelmed by masked figures whose bloodless faces and garish red mouths embody the artist's obsessions: a fear of his fellow men, especially in the mass; the abysses of human nature; cruelty lurking beneath the bland appearance of things.

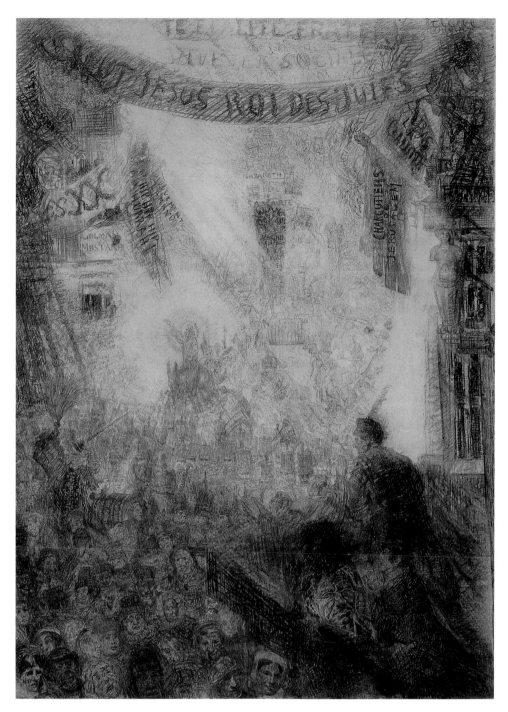

The Great and Glorious Entry of Christ into Jerusalem, 1885
Crayon and pencil on paper, mounted on canvas,
207 x 152 cm
Ghent, Museum voor Schone Kunsten

"This is a drawing which caused a great controversy at the 'Les Vingt' salon in the year 1887. Ensor wished to depict a God of the poor in an extraordinary glory in which grotesque fantasy and the purest sublimity of light were united" (Eugène Demolder, in the first biography of Ensor, published 1892).
A stream of people flows through a Brussels street. The contours of the figures seem to dissolve in the brilliant light. The allusion to Christ and the biblical event gives Ensor an opportunity to describe his own position as outsider and redeemer of Belgian art.

comparable to Christ, founder of a religion and a revolutionary, like Littré. In his combination of apparently disparate themes (philosophical skepticism, political and social issues, outsider's position), Ensor proves himself to be a truly modern artist who is capable of convincingly linking different levels of meaning and – similarly to the Cubists to follow – of employing the means of collage to fix in a single image the simultaneity of non-simultaneous occurrences and viewpoints.

 Ensor's often harsh and hermetic visual language is open to countless interpretations, and though great numbers of letters and statements of his are preserved, he almost never spoke of the meaning of his pictures, or of the intentions behind his compositions and figures. Ensor's statements are at times extremely cryptic, frequently ironic or sarcastic in tone, and sometimes self-contradictory in every respect. For instance, he once spoke of Rubens with reverence, saying "J'adore Rubens, votre père, le Créateur du Ciel et de la Terre" (I worship Rubens, your father, Creator of Heaven and Earth), yet he was equally capable of scoffing at him as a "fool in velvet and silk." Like his paint-

ings, Ensor's writings are shot through with contradictions. The earliest collection of writings was published in 1904 in Ostend, and it was followed over the course of the years by several further publications: lectures, treatises, and correspondence. These too confront us with an artist involved in an incessant process of self-stylization, spinning out his own legend. Ensor plays with syntax and semantics; evidently nothing gave him more pleasure than confusing the public. Yet in person, the impression he made was apparently that of an unapproachable, almost arrogant man, as is so often the case with people who are inveterately shy.

In 1960 a comment by the critic André de Ridder provides an interesting insight into Ensor's congenital aloofness: "I have the impression that he needed solitude in order to continually develop his introspection. He preferred to entrust what he wanted to convey about his real persona to his oil paintings and etchings, and sometimes to a sheet of paper – a written article, a speech, a letter... In general he was content to declare that he himself did not know exactly what he had actually wanted to say in a particular painting or etching, that he had no aesthetic doctrine to defend, and no philosophical or political views to propagate...".

The year 1888 saw the emergence of *The Entry of Christ into Brussels in 1889*, Ensor's largest, most popular, and certainly also one of his most difficult works. Here, too, the point of departure is a biblical story, concerning the entry of the Savior into the city of Jerusalem. This time Ensor addresses the subject in a literally overwhelming way: the picture measures over ten square meters in area! To avoid the expense of buying oil paint in tubes, the artist had lacquer of the proper consistency prepared for him by a master house painter, and applied it to the canvas in great swaths of unmixed colors – red, green, yellow and blue, set off from each other by white – colors like trumpet fanfares, saturated, pure chords of color.

In his attic studio Ensor was able to attach only a small section of the canvas support to the wall at any one time; the other sections lay, rolled, on the floor, so that he was never able to view the work as a whole as it was developing. It was not until 1917, when he moved into the house in Rue de Flandre inherited from his uncle, that Ensor was finally able to hang the picture, a full twenty-nine years after its execution. Numerous visitors had the opportunity to admire it there. (A replica now hangs in the house. The original went in 1987 to the Paul Getty Museum in Malibu, California.)

As far as the subject matter of the picture is concerned, Ensor seems to have been fascinated by the "thousand-headed" crowd, which he depicts as a motley collection of variously characterized figures. The figures confront us like an encyclopedic array of physiognomic character types, and the teeming, seemingly endless variety of faces and masks, including a bishop leading the procession, a judge in a red robe, and a highly bemedalled officer, relegates the figure of Christ/Ensor on a donkey very much to the background. At this second plateau, in the center of the picture, behind the closed line of regimental musicians whose blue-black shakos form a horizontal accent, Christ/Ensor rides through a gauntlet of bizarre figures who bow down to him. Following the "Redeemer" is a train of costumed figures that seems to extend infinitely into the depths of the picture. Here we see, for the first time on a large format, Ensor's urge to fill a canvas completely, leaving not the slightest gap. This "horror vacui" or fear of an empty canvas seems strangely opposed to (or perhaps compensates for) the artist's fear of real crowds, on the street, at the beach, or during the Carnival revels in Ostend. Flags, banners and banderoles project far into the picture and partially obscure the mass of people. The slogan "VIVE LA SOCIALE" (Long Live Social Progress) on a fire-engine-red banner leaps to the eye; as a formal device it serves to frame the image at the upper edge of the canvas. The masses are driven in their inexorable advance towards the foreground by the

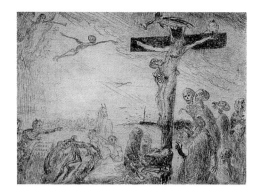

Satan and His Fantastic Legions Tormenting Christ Crucified, 1886
Charcoal and pencil on paper, 61 x 76 cm
Brussels, Musées royaux des Beaux-Arts de Belgique

The extreme contrasts of light and shadow in this drawing point up the influence of Rembrandt on Ensor.

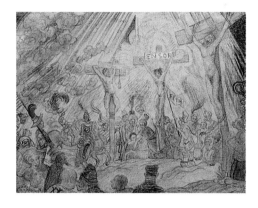

Calvary, 1886
Colored pencils on wood, 17.2 x 22.2 cm
Private collection

The art critic Edouard Fétis administering Ensor/Christ the "coup de grâce."

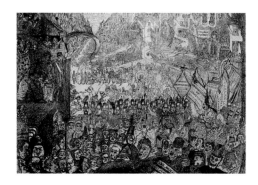

The Entry of Christ into Brussels, 1898
Etching on Japan, 24.8 x 35.6 cm
Brussels, Bibliothèque Royale Albert 1

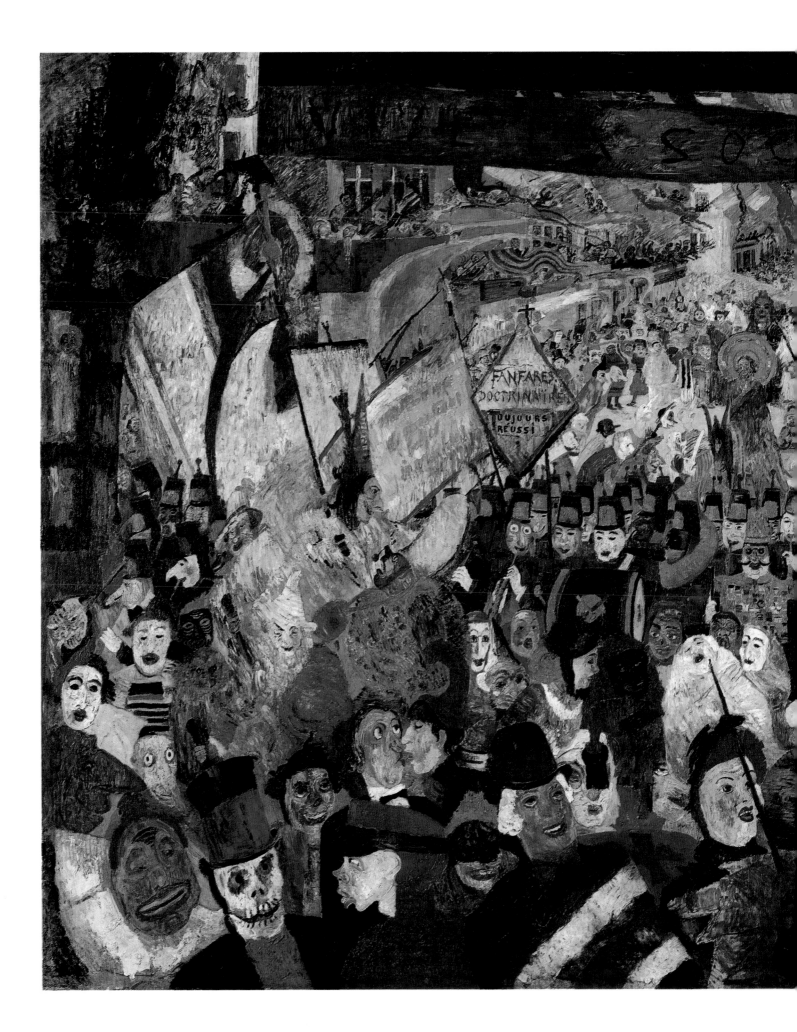

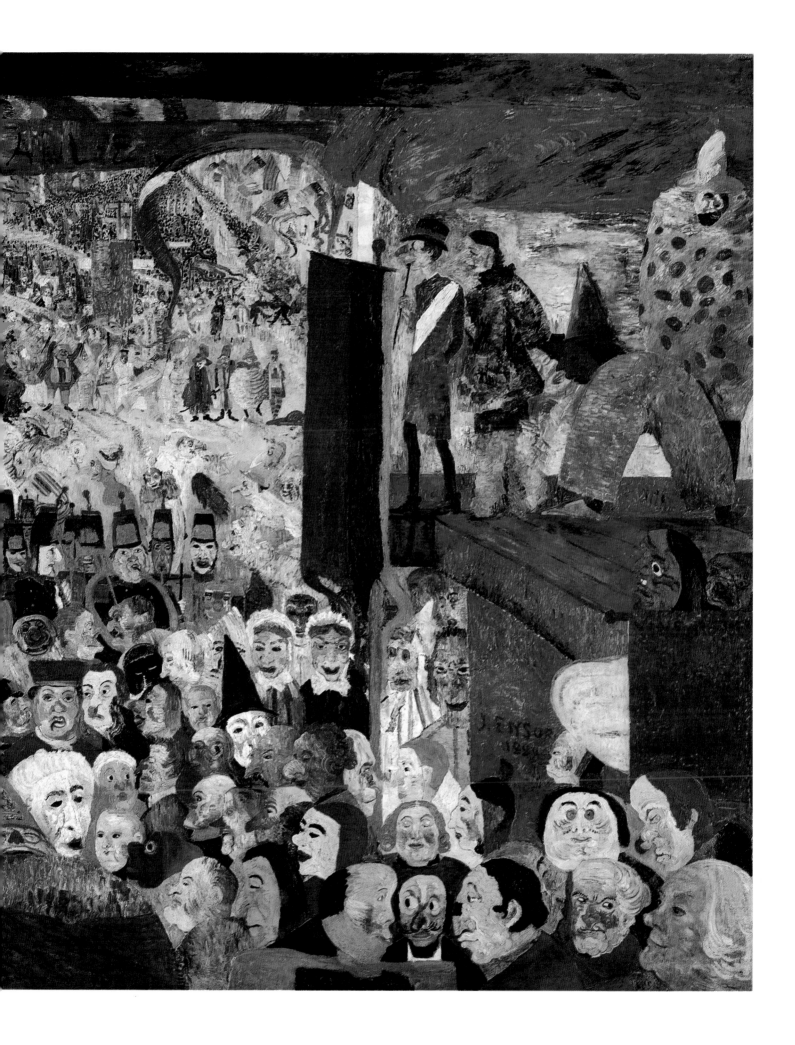

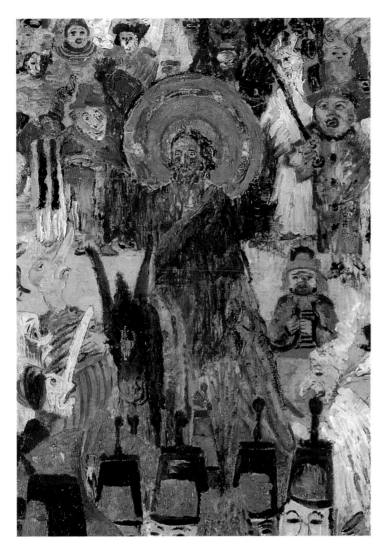
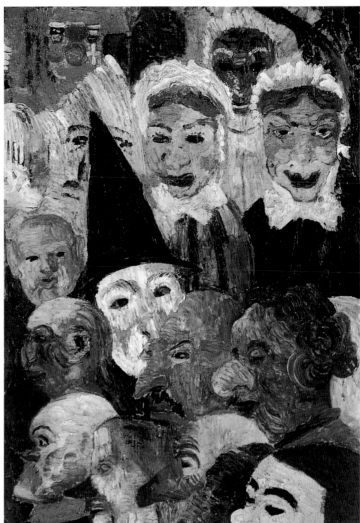

"FANFARES DOCTRINAIRES TOUJOURS REUSSIES" (Never-Failing Fanfares of State Power).

Under the green dais at the right we recognize a face from *The Scandalized Masks*, and to the left of it, Ensor's sister Mitche is depicted. The skull wearing a top hat in the left foreground recalls the groom in *The Intrigue* (p. 58/59). Apart from allusions to the artist's family, this phantasmagorical Carnival parade also contains numerous references to figures in Belgian political and social affairs, in literature and art history.

The grotesque, ridiculous faces in the foreground stand in graphic contrast to the main figure in the middle ground, rendered in a softer manner, in warm colors, a magnificent halo surrounding his head. Ugly and laughable, pressing and threatening in their motley, garish costumes and make-up and masks, they advance towards the viewer like an unstoppable human river. We may assume that Ensor himself must have felt, as it were, the hot breath of the crowd on his neck, and escaped by slipping into the persona of his alter ego, Christ, who as central figure blesses the masses as he rides dignified into Brussels. Christ, with whom Ensor identified even down to physical appearance, was the focus of his yearning to himself become a redeemer or savior – that is, to at last receive the recognition due him as a revivifier of Belgian art and enter victoriously into the capital.

All of these distorted figures – long-nosed or sheep's faces, jeering burghers, and maliciously grinning masks – are autobiographical to the extent that they convey Ensor's anger and disappointment at a town and its populace that not only did not understand him but scoffed and joked about him. The art colleagues who declined to exhibit his pictures, the family who considered his work

PAGES 46/47 AND DETAILS ABOVE:
The Entry of Christ into Brussels in 1889, 1888
Oil on canvas, 252.5 x 430.5 cm
Malibu (CA), The J. Paul Getty Museum

This major work of Ensor's is considered his expressionist manifesto and artistic legacy. In the phantasmagorical Carnival parade the artist sums up his obsessions and anxieties, his penchant for satire and sarcasm, his sociopolitical and moral ideas.
The painting remained rolled up in Ensor's attic studio for over 30 years; not until 1929 was it exhibited for the first time. Until 1987 it was on loan both to the Antwerp Museum and the Kunsthaus Zürich. In that year it was acquired by the J. Paul Getty Museum in Malibu, California. The two details show Christ-Ensor as a dispassionate healer giving his blessing to the mob, unaffected by the raging assembly of feisty and mockingly grinning mask-faces, which include depictions of members of Ensor's family.

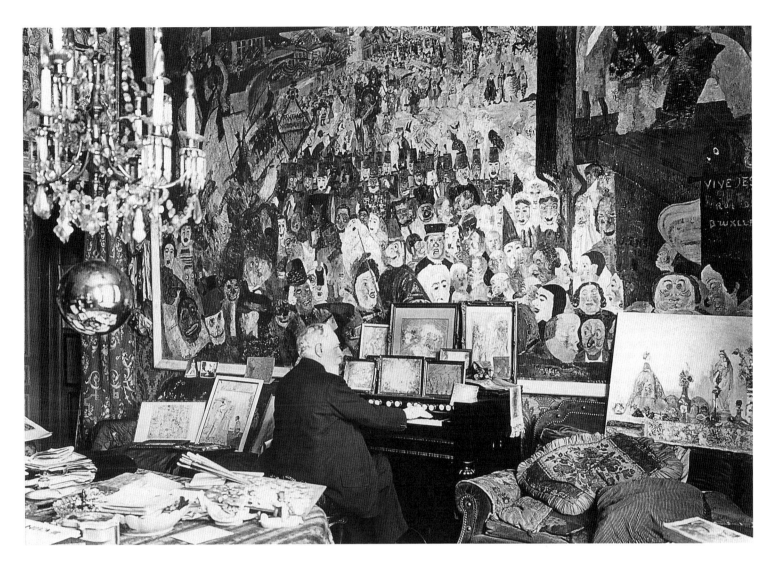

Ensor seated at the harmonium, *The Entry of Christ into Brussels* in the background, 1937

nothing but a waste of time, the art critics who ignored or derided him, the good citizens of Ostend who thought him crazy – all of them are present in the picture. In a way that had no precedent in art history, Ensor revolted against this situation and showed the world to be an endless Carnival parade of more or less infantile people filled with malice, stupidity, deviousness, and ignorance.

Ensor projects a grandiose panorama of scurrilous fantasy figures, rendered in garish colors whose effect is heightened by accents and passages of white and black. In his own words, "Christ's Entry into Brussels – here swarm all the little hard and soft creatures spit up by the sea... Overcome with irony, excited by the magnificence, my vision is sharpened, I clarify my colors, they are wilful and personal." Emile Verhaeren wrote about the picture: "One sees here the God and man, grotesquely inserted into the midst of our paltry, violent, quotidian quarrels. He reviews the exciting and tumultuous parade of our political and social demands, like any banal representative, mayor, assistant, deputy, on a day of unrestrained demonstrations... No doubt the work teems with mistakes of composition and perspective, but its palette is magnificent. The blue, red, green tones, either juxtaposed or set off from one another by broad white areas, have the effect of a fanfare of pure notes, and their daring, occasionally brutal mixture exerts a lyrical effect on the eye."

As work on the painting progressed, Ensor reputedly added ever new faces to it, for instance when he returned from a walk through Ostend. The constricted space of his studio, which prevented him from ever seeing the whole canvas at once, may possibly have led to the picture's lack of stylistic unity. Summarily rendered passages are found alongside carefully worked ones, transparent areas alongside opaque, shaded, three-dimensional depictions alongside flat ones.

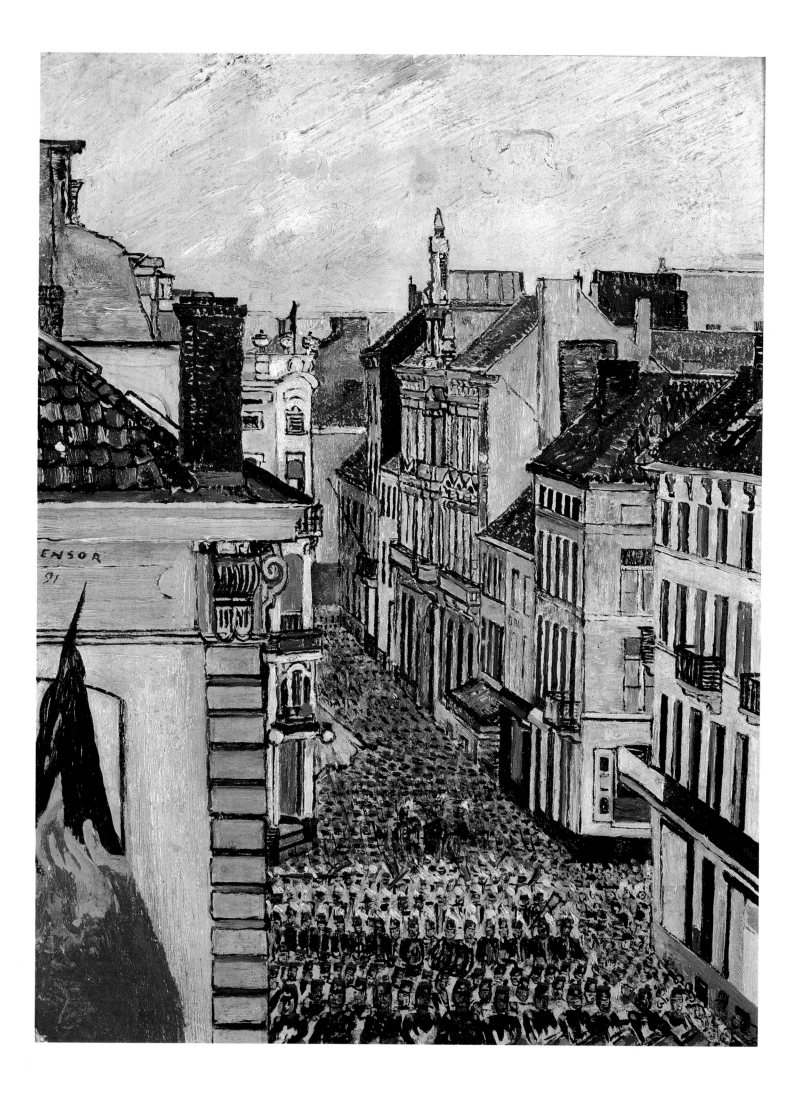

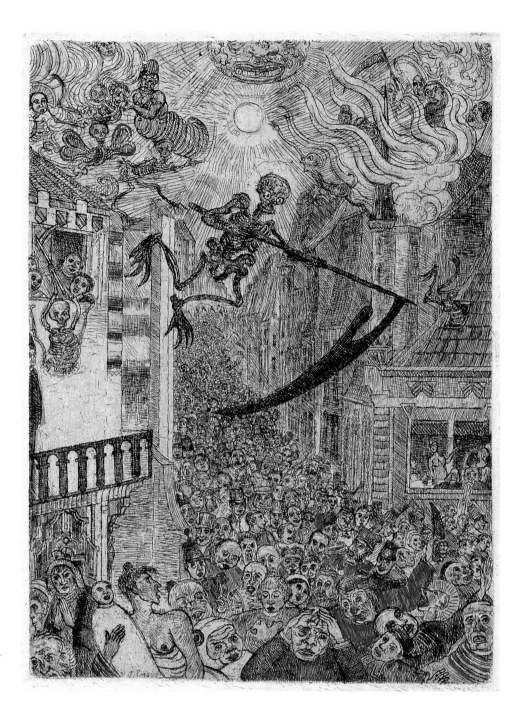

Death Pursuing the Human Herd, 1896
Etching on Japan, 23.4 x 17.5 cm
Collection Mira Jacob, Paris

Here Ensor addresses the medieval theme of the
Dance of Death, but enriches it with a motif spe-
cifically his own: the endless mass of humanity.
The narrow canyon-like street recalls *Music in
the Rue de Flandre*, yet here we see not an order-
ly parade but a chaotic crowd rushing towards us
in panic, in an attempt to escape its pursuer.

PAGE 50:
Music in the Rue de Flandre, 1891
Oil on canvas, 24 x 19 cm
Antwerp, Koninklijk Museum voor Schone
Kunsten

From his studio window Ensor could look out
over Rue de Flandre and observe from a distance
what took place there, including frequent Carni-
val processions and military parades. The pre-
cisely drawn contours and signal-like colors of
the present canvas seem like a visual correspond-
ence to the sounds of a military march.

As might have been expected, no one showed any interest in Ensor's magnum
opus. *The Entry of Christ into Brussels* was first exhibited only in 1929, forty-
one years after its execution.

In contrast, another large-format painting caused a furor in Brussels toward
the end of the 1880s: Georges Seurat's Post-Impressionist masterpiece, *A Sunday
Afternoon on the Ile de la Grande Jatte* (206 x 306 cm). The pointillist style of
Seurat (1859–1891) found a number of imitators in Belgium, including Willy
Finch, the young Henry van de Velde, and Théo van Rysselberghe. Ensor was
baffled by the fuss made over the Frenchman's painting. He thought Pointillism,
with its tiny, regularly placed dots of paint, vapid and academic, and rejected it
as "an art of cold calculation and limited vision." Like so many artists who live
a solitary life, whose thoughts and activity revolve primarily around themselves,
Ensor saw in every successful colleague first and foremost a rival, especially
since he was disappointed that his originality, his genius, was not recognized by
the others. In this connection, Heusinger von Waldeck advances the hypothesis
that Ensor's huge painting may have been a direct and conscious reaction to
Seurat's *Grande Jatte.*

The madding crowd as a threat, a nightmarish one, was a theme taken up in many other Ensor paintings in the wake of *The Entry of Christ into Brussels*. As he spent day after day in his fourth-floor garret, the artist developed a virtually panic fear of crowds. The masses, as a political and social force emerging from the streets, took on ever greater meaning as the nineteenth century progressed, signifying hope to some, danger to others. In 1895 Gustave le Bon (1841–1931), in his book *Psychology of the Masses*, brought the fears of the bourgeois world in face of the "unleashed" lower classes to a focus in the assertion that without the leadership of a "small intellectual aristocracy" the masses would possess nothing except the "power of destruction. Their domination always implies a phase of disintegration."

The Kingdom of Belgium, at the end of the 1890s the most densely populated country in Europe, experienced frequent protest meetings and demonstrations, most of them directed against the church and the king, Leopold II. The demands raised by broad sectors of the population in part conformed with Ensor's own revolutionary ideas; he put them, if sometimes ironically, into the slogans and epigrams in his paintings, and thus took a stance with respect to the important political and artistic issues of the day. Yet as we have noted, Ensor's attitude towards the masses was ambivalent, reflecting fear and rejection on the one hand, sympathy and an urge to solidarity on the other. So here, again, it would seem safe to assume that Ensor's work was not least a way of exorcising the demons that oppressed him in his daily life.

In his tale "The Man of the Crowd," Edgar Allan Poe, whose writings Ensor valued highly, describes people in the mass as a conglomerate of figures each concerned solely with himself and his own affairs, passing through the streets in isolation from the rest. Ensor's depictions of crowds seem dominated by precisely the same traits. To the unfeeling, rough, blind mass he contrasts the self-aware individual, perhaps an artist or intellectual, whose worldly ability to think and articulate alone makes him stand out from the crowd.

From his dormer window Ensor overlooked the Rue de Flandre and its streams of passersby, and he probably missed no Carnival procession, demonstration, or military parade that took place there. Yet unlike the Impressionists,

PAGE 53:
The Cathedral, 1886/1933
Etching, colored in chalk by the artist in 1933,
23.5 x 17.5 cm
Slijpe (Belgium), James Ensor Archief,
P. Florizoone

Ensor created a total of 133 graphic works, a first series between 1886 and 1889, a second between 1895 and 1899. *The Cathedral* is among his finest etchings and one of the earliest instances of his employment of the theme of people in the mass.

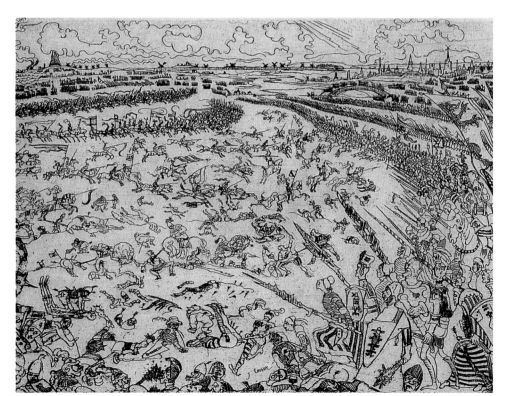

Battle of the Golden Spurs, 1895
Etching on old ribbed wove, 17.3 x 23.7 cm
Brussels, Collection Crédit Communal – Dexia

In this etching Ensor refers to a battle between Flemish and French armies in the year 1302, in which the former were defeated. "*The Battle of the Golden Spurs* is a county fair where they kill for fun, fall for entertainment, and die out of a fondness for making faces" (Emile Verhaeren).

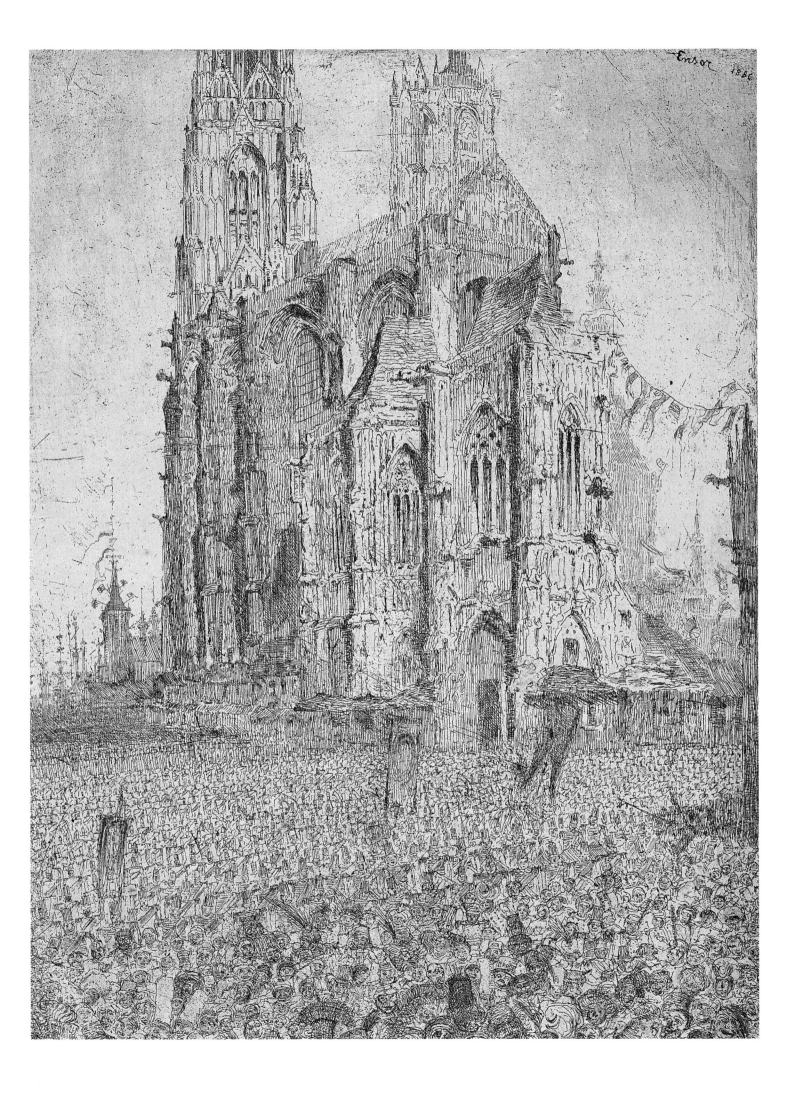

Beach and Promenade at Ostend, postcard, c. 1895

whose streets and squares are filled with people out enjoying the air, Ensor shows the street – as in *Music in the Rue de Flandre* (p. 50) – as a place teeming with an amorphous stream of blindly pushing and jostling humanity. With its precise drawing, clear contours, and bright Fauvist color scheme, this canvas differs fundamentally from the street scenes of the early 1880s, which were beholden to Impressionism. Now the houses seem to reverberate with the rhythm of the marching band, the black lineatures of the facades and the red roofs to tremble with the noise of brass and drums.

From this point on, street and crowds seem to belong indissolubly together for Ensor. Yet the street, instead of presenting an open path, becomes a bottleneck, even a trap. This is especially the case in the etching *The Triumph of Death* (p. 51), 1896. Death, the Grim Reaper with vulture's claws, falls upon a panicking crowd of people. Except for a mother and her child, everyone has only one thing in mind – to save his or her own skin. And thus, as so often with Ensor, people in the mass, instead of forming a homogeneous group as might appear at first sight, prove to be a mob comprising an infinite number of isolated individuals.

As Wilhelm Fraenger has pointed out, the occurrence of crowds in Ensor's work tends to be independent of subject matter. Whether he represents the story of Christ, a street scene, or a beach scene, the motif is invariably linked with a teeming horde of grotesque figures. Since this pictorial emphasis is not necessarily related to the subject proper or derivable from it, the reason for Ensor's concentration on crowds is probably to be found in his own personality. According to Fraenger, it is a manifestation of Ensor's fear, as a lone, isolated artist, of being engulfed in the mass, which levels all individuality and threatens a loss of identity.

In addition to this aspect, Ensor's depictions of masses of people have a significance for pictorial structure that cannot be overestimated. They contribute fundamentally to the rhythmical pattern of the compositions. Ensor contrasts order with disorder, form with chaos, to create an impression of incessant motion, inexorable dynamic energy. In the midst of the surging mass, the individual must relinquish all claim to personal significance; he becomes, as the saying goes, a drop in the ocean. This becomes especially clear in an etching titled *The Battle of the Golden Spurs* (p. 52), in which the artist alludes to a bloody conflict of the year 1302 between well-armed French troops and poorly armed Flemish.

This motif is also treated in one of Ensor's best known graphic works, *The Cathedral* (p. 53), an etching of 1886. Here a homogeneous group of marching men entering the picture diagonally from the right is contrasted to a dense, seething mass of figures, some ordinary, others quite bizarre. In this case, too, order is set against chaos, discipline against anarchy. The composition evokes great space and depth, an effect produced not least by the differentiated arrangement of the various streams of people, which seem to move both vertically and diagonally, both out of the picture and into the depths of the suggested space.

But what is the actual theme of this masterful small etching, which Ensor executed at age twenty-six? Does it represent a Carnival parade or a military maneuver? Or is the area around the church perhaps being cleared of a mob by the police or army? What meaning attaches to the Gothic church that soars above the scene, to which the artist was inspired, as we now know, by three different churches – its nave by Aachen Cathedral, its left spire by St. Stephan's in Vienna, and its right, unfinished spire by the cathedral in Antwerp? And what about the trembling, interrupted lines used to represent the nave? Some commentators (Haesaerts, for instance) interpret these as an artistic device intended to lend the building a certain lightness and transparency, heightening the contrast to the seething, closed-pressed mass. Others (including Fraenger) see the

church as being caught in a process of disintegration and decline, symbolizing Ensor's attitude to organized religion. The way the faces of the people in the foreground all turn in the same direction suggests that the crowd is concentrating on some event or person outside the picture.

A quite different, carefree, and highly satirical view of the crowd is presented in *The Beach at Ostend* (p. 55). Here Ensor focusses on the seaside recreations of the common people, playing themselves out under the supercilious gaze of the town's upper crust. Harking back to the burlesque scenes of Pieter Bruegel, Ensor stages a comedy of manners complete with extremely candid erotic interludes, which caused even the "progressive" artists of *La Libre Esthétique* (the successor of "Les Vingt") to reject the picture, horrified. King Leopold II, on the other hand, noted in amusement, "Monsieur Ensor has done the subject very well; he has not exaggerated, this is exactly how one bathes in Ostend. The sea and bathing do sometimes hold pleasant surprises in store for us."

The Baths at Ostend, 1890
Black crayon, colored pencils, and oil on wood, 37.5 x 45.5 cm
Private collection

A light-hearted, satirical depiction of life on the beach at Ostend. Like the great Pieter Brueghel before him, Ensor delineated grotesque scenes, but some of a so explicitly erotic nature that the "Les Vingt" group indignantly rejected the picture.

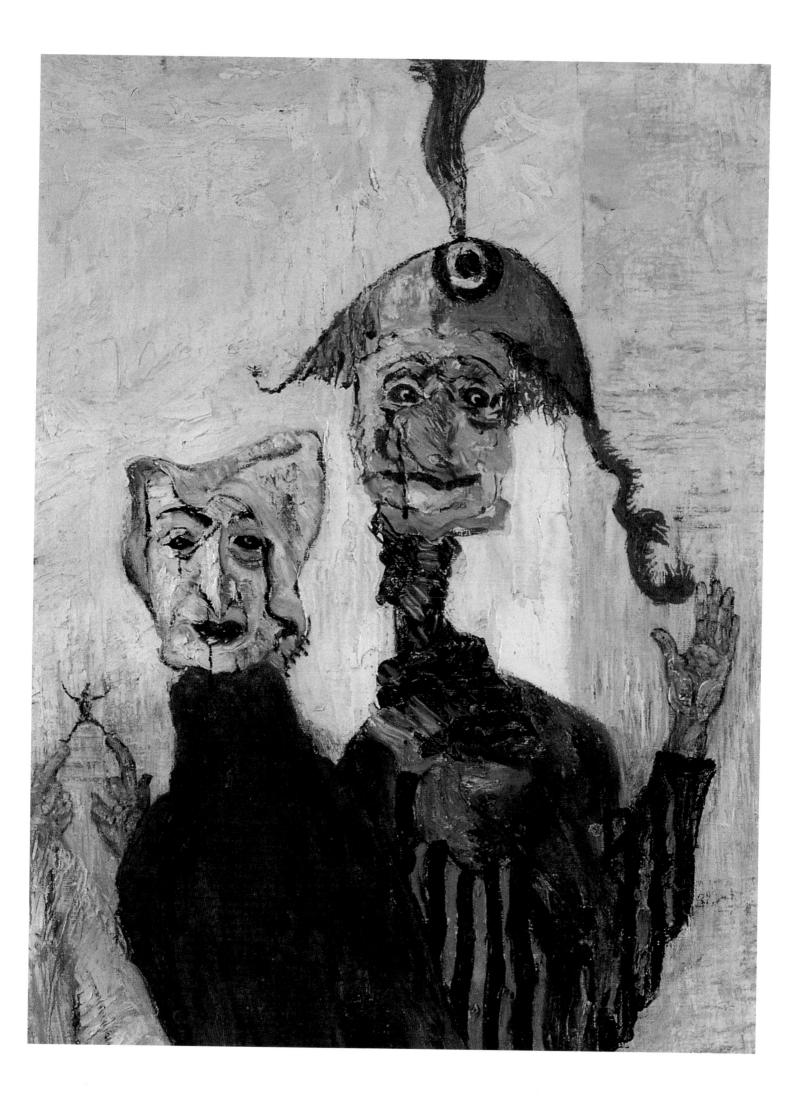

Behind the Mask

I have serenely banned myself to that solitary milieu in which reigns the mask – all violence, light and majesty. The mask means to me: freshness of tone, exaggerated expression, sumptuous decor, great, unexpected gestures, uninhibited movement, exquisite turbulence." In metaphorical, pathos-charged language, Ensor explains his turn to the motif of the mask, which means much more to him than costume party or Carnival. If his first work devoted to the theme, *Scandalized Masks* (p. 38), still features a naturalistic depiction of a costumed pair whose identity is concealed behind masks, Ensor's subsequent paintings develop the mask from little more than an attribute into a substantial trait of the persons depicted. These bizarrely tragic figures, more properly apparitions whose personalities themselves are like masks, reflect Ensor's inner world, his anxieties, his visions.

Obviously the employment of the mask motif can be traced back first and foremost to the legendary Carnival tradition of Ensor's native town. The revels, which can at times run to orgiastic excess, find their official culmination in the "Ball of the Dead Rat," a parade that still takes place annually in Ostend. All over town, the streets teem with disguised and masked figures, a grotesque and occasionally uncanny pageant. In Ensor's time, the Ostend Carnival was known throughout Belgium as beyond compare.

But Carnival not only represents a welcome break from the daily monotony, a brief, enjoyable diversion. At the same time – and particularly with regard to Ensor – Carnival stands for an alternative world, an anarchistic world in which "real" social and political circumstances are turned upside down, taken ad absurdum, made to look ridiculous.

Of his family, Ensor's grandmother was especially fond of assuming disguises. Ensor too loved to slip into strange roles, and with his friend, Ernest Rousseau, he would roam the streets of Ostend unrecognized, emitting bloodcurdling screams when the fancy took him. His mother's shop provided a broad and diverse selection of paper maché masks, harlequins and demons, skulls, animal heads, and more.

Asiatic or African masks of the kind that would be so important to Expressionism, on the other hand, are seldom found in Ensor's work. In fact he flatly rejected what he saw as the primitivism of African masks: "I condemn without forbearance the incompetent masks from the hellholes of Africa, fie on the lineaments of the cheap, outmoded charms of negroid or gorilla-like fetishism." In contrast, the variety of form and color in the carnival masks of his Flemish homeland appealed greatly to Ensor, who, in a letter to Albert Croquez, described them (coining a series of French adjectives that do not go easily into English) as "... clad in tenderness, spiced with prettiness, purple, azure blue, mother-of-pearly, shell-like, oysterish, embossed, striped, turboty, bearded, coddy, floundery, rascally, embued with imagination, they are exuberant to their hearts' content."

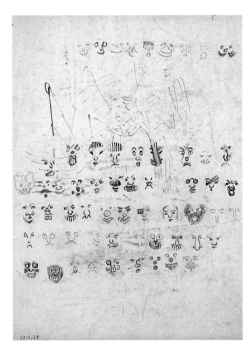

Row of Masks, 1885
Conté crayons on paper, 22.4 x 17.5 cm
Antwerp, Koninklijk Museum voor Schone Kunsten

Ensor systematically tested various methods of alienating appearances, including the stylistic means of caricature: exaggeration, foreshortening, distortion.

PAGE 58/59:
The Intrigue, 1890
Oil on canvas, 90 x 150 cm
Antwerp, Koninklijk Museum voor Schone Kunsten

PAGE 56:
The Strange Masks (detail), 1892
Oil on canvas, 100 x 80 cm
Brussels, Musées royaux des Beaux-Arts de Belgique

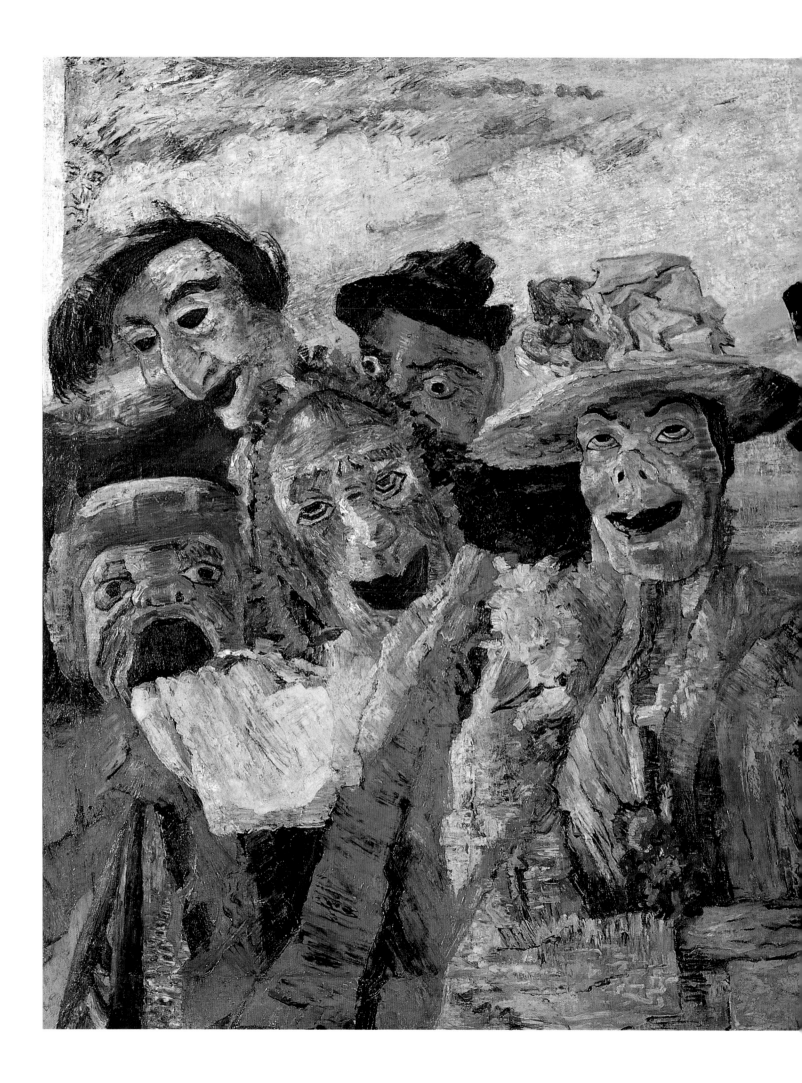

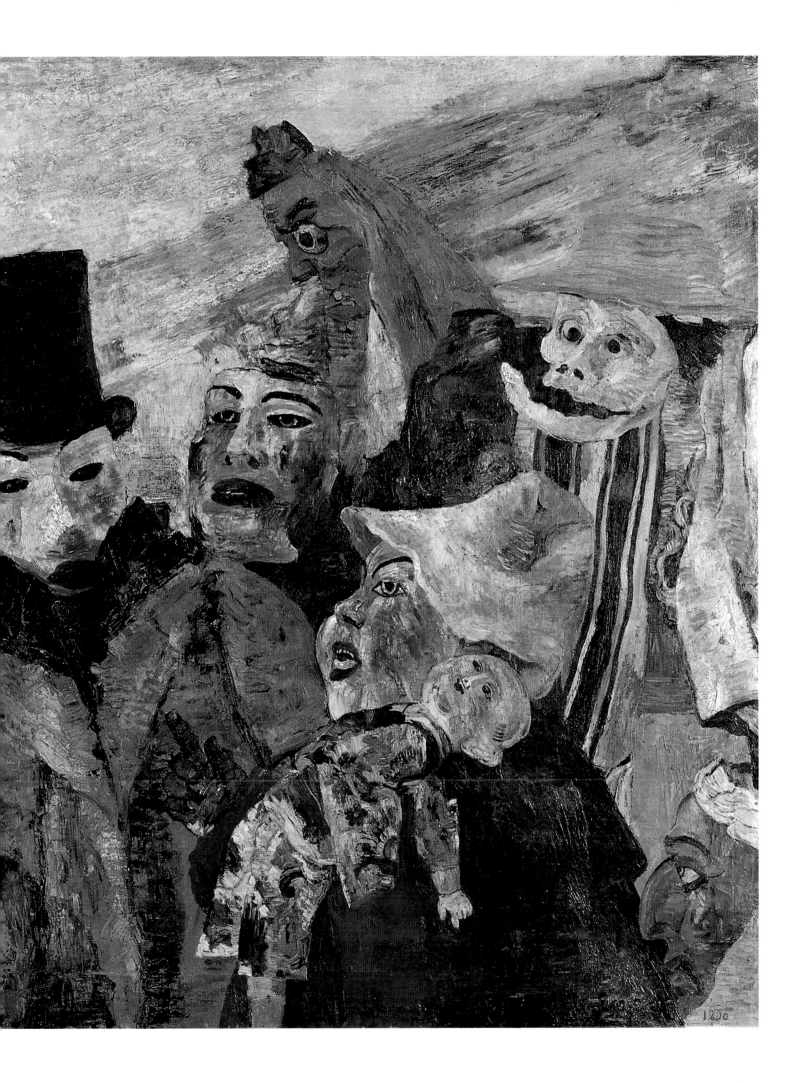

In his paintings Ensor projected an entire universe of masks. There is a sur-
viving sketchbook page that illustrates his amazing skill in capturing a variety of
facial expressions and grimaces with only a few rapid lines. He uses devices that
are well known from caricature: exaggeration, foreshortening, distortion. In
Ensor's hands these result in a plethora of the most abstruse physiognomies,
from grim faces with empty eye sockets and leering mouths to ordinary every-
day faces that stare dumbly at the viewer with a mocking grin (pp. 1 and 57).

From now on, the motifs of mask and mass belong indissolubly together, the
threatening mass corresponding to the ugly, hypocritical mask-face. Sometimes
face and mask blend to the point that it is difficult to say where one begins and
the other leaves off. Take *The Strange Masks*, a painting of 1892 (p. 66). What
does it confront us with – grimacing human faces, masked figures, or masks
which have taken on a life of their own?

First and foremost, the mask in Ensor serves to conceal someone's true face.
In *The Intrigue* (p. 58/59), 1890, a group of people presses around a couple in
the center, their faces full of enmity disguised by apparent appreciation. It has
been suggested that the couple represents Ensor's sister Mitche and her Chinese
husband. However, this seems unlikely, since Mitche did not marry until 1892.

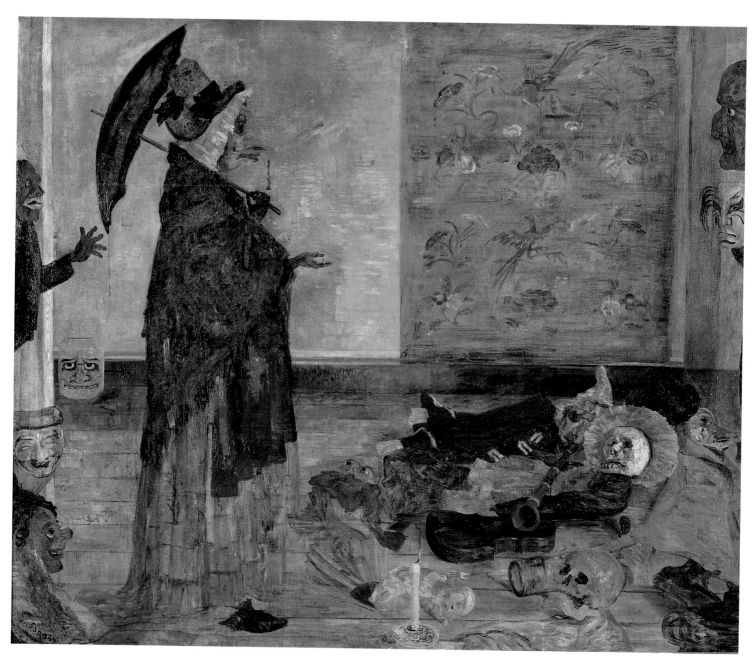

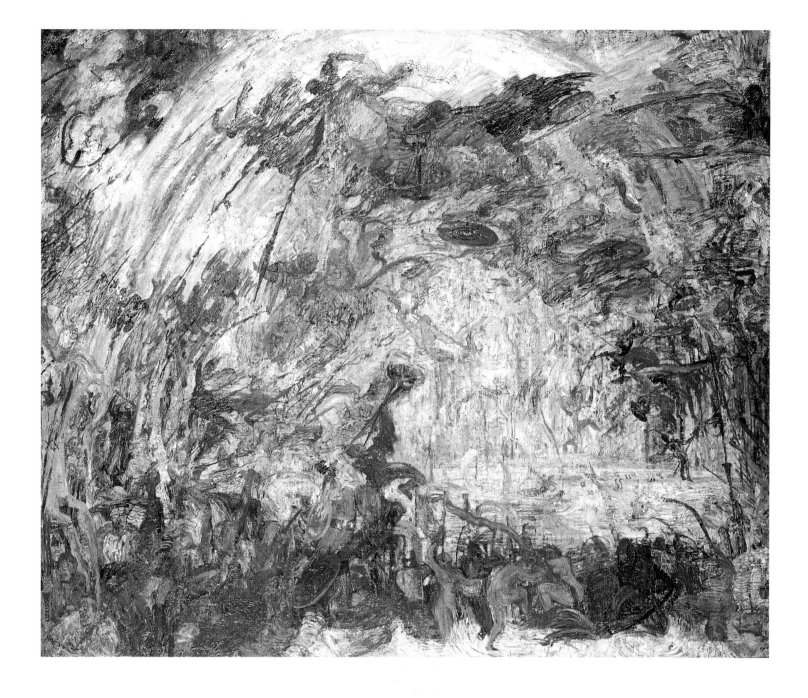

Observing the people swaying tipsily to and fro, the figure of Death enters the scene from the right, as if both a participant in the bizarre party of life and a reminder of its fleetingness, a "memento mori." Like the green mask with the fishy eye bending over him, Death is rendered in a flat, planar way. Are these two merely observers of the conspiracy, or are they perhaps accomplices or even instigators? Is the groom being protected from the encroaching crowd by the bride, or is she pushing him gently to what she must know is his fate? Might not the artist himself lurk behind the groom's mask, more or less helplessly subject to the mocking and practical joking of those around him? Whatever the case, mask paintings such as this one provided Ensor the opportunity to confront an arduous reality with his own, personal fantasy world.

The Intrigue is justifiably seen as one of Ensor's masterpieces. Rendered in strong colors laid on in expansive planes, the picture evokes such feelings as mockery, contempt, hypocrisy. Ensor's *Intrigue* is a consummately modern painting, in that it addresses in a radical way the tragic situation of the unsuccessful artist and his precarious position within society. Moreover, it anticipates certain traits of later Expressionism, such as those seen in the works of Emil Nolde from the 1910s and 1920s.

The Fall of the Rebellious Angels, 1889
Oil on canvas, 108 x 132 cm
Antwerp, Koninklijk Museum voor Schone Kunsten

In this orgy of paint Ensor exhibits his skills as a passionate Expressionist. The forms of figures and objects almost entirely dissolve in a veritable inferno of color.

At this juncture definite changes in terms of approach began to make themselves felt. *The Intrigue* might still be considered a basically realistic picture, the bluish-grey cloudy background, for instance, being clearly recognizable as a typical North Sea sky. Yet the mask paintings of the 1890s can no longer be described as realistic by any stretch of the term. The palette becomes lighter, more brilliant, and at the same time more aggressive, while the content of the works increasingly takes on the character of phantasmagoria.

A first premonition of developments to come is found in *The Astonishment of the Mask Wouse* (p. 60) of 1889. An old woman wearing a mask – or with a mask as face – stands before a pile of clothing, masks, and musical instruments scattered on the floor. Though one can distinguish certain articles such as a uniform jacket, a top hat, or a lace bonnet, much of the collection eludes identification, remaining mere swaths and dabs of paint. Various figures and masks intrude upon the scene from the picture edges. A light-green Chinese tapestry with bird and plant decor hangs on the wall of the room at the right. On the floor, hardly detectable in the labyrinthine confusion of forms and colors, stands a burning candle. In this grotesque ambience the old woman seems to represent the sole "real" thing – but what to make of the strange ornament dangling from her nose (or is it simply dripping?) and the clawlike hands? And what about the illumination, which seems to suffuse both opaque and translucently rendered passages in equal measure, making the scene appear to oscillate between reality and fiction? Might there again be autobiographical aspects involved, in the sense that Ensor shows us his artist's power to reveal a world that has hardly anything in common with the quotidian one? In this case the old woman might well represent the pragmatic attitude of the women in his family, contrasted to ghostly apparitions as embodiments of the artist himself and his imaginative companions. Or is the mask "Wouse," as Robert L. Delevoy suggests in his Ensor monograph, actually a representation of Death, concealed beneath Carnival finery?

At the same period Ensor painted *The Fall of the Rebel Angels* (p. 61), which differs completely from *The Mask Wouse* as regards both theme and painting technique. Here, by means of what one is tempted to call an "unleashed" illumination, the artist projects a world in which all objects seem to dissolve, a veritably apocalyptic vision. The subject of falling angels prompts a true explosion

Attributes of the Studio, 1889
Oil on canvas, 83 x 113 cm
Munich, Neue Pinakothek

An absurd conglomeration of ordinary objects and fantastic apparitions in which reality and fiction intermerge.

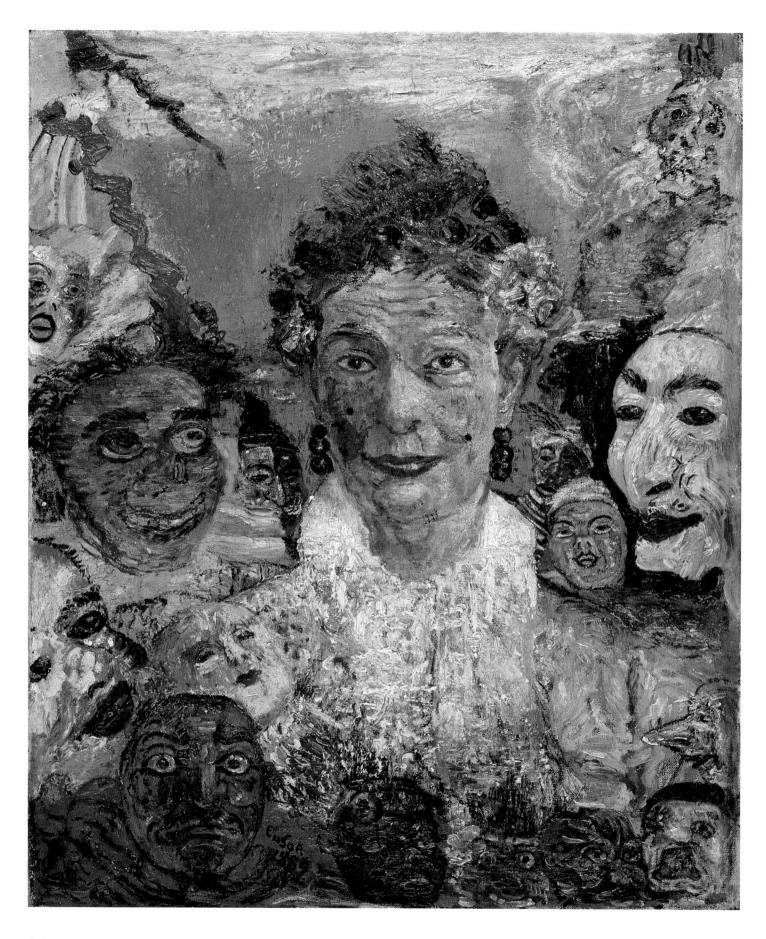

Old Woman with Masks, 1889
Oil on canvas, 54 x 47,5 cm
Ghent, Museum voor Schone Kunsten

The *Old Woman with Masks* is a distillation of
Ensor's art (Paul Haesaerts).

of color, of a violence that recalls the much later expressive painting of a Hans Hartung (1904–1989) or a Jackson Pollock (1912–1956). A comparison of this picture with the *Tribulations of St. Anthony* (p. 36/37) done just two years previously sheds light on Ensor's development towards a radically subjective, emotion-charged, expressive approach. While the rendering of light in *Tribulations* still seemed influenced by Turner – with a central light source, semicircular reflections, and corresponding effects of illumination on the water and in the sky – *The Fall of the Rebel Angels*, despite a similar basic composition, is an orgy of expressive color, a sheer inferno, a dramatic vision that truly evokes the end of the world.

Old Woman with Masks (p. 63), also executed in 1889, might be described as a transformation into a fantastic composition of a subject previously treated naturalistically. The point of departure here was a portrait of the author Neel Doff, a commissioned work which the sitter found unsatisfactory and rejected. Ensor avenged himself by reworking the lady's face, which is said to have been beautiful, into a rigid countenance with staring, empty eyes, beauty spots, and beard stubble. Apparently the grinning or frowning masks and death's heads have already cast their magic spell over the poor sitter. Under their invocations, youth and beauty have wilted, the face metamorphosed into an ugly mask.

Attributes of the Studio (p. 62) similarly shows an array of diverse faces and masks, which appear to stare at the painting utensils on the table in front of them. In the center of the picture stands a statuette of an athlete in a classical pose with a doll standing on his shoulders. Around him are arranged, in a seemingly natural way, plates, open books, a palette, and a cello – references to painting, literature, and music, those fields which were so important to Ensor's own life. Yet there are also interspersed passages of color which correspond to no real objects, such as the red, green and blue field in the right foreground, which stand only for themselves. This engenders an additional, estranged level of reality, which in turn casts a new light on the "real reality" occupied by the identifiable objects. Reality and fiction seem to interpenetrate without transition. This is one of the key marks of Ensor's painting: it remains largely enigmatic, and resists clear and definitive interpretation.

Between 1884 and 1893 Ensor exhibited regularly in the "Les Vingt" salon, but from year to year, he found less recognition. In the eyes of the critics his

Masks in the Ensor-House, Ostend

PAGE 65:
Skeletons Trying to Warm Themselves, 1889
Oil on canvas, 74.8 x 60 cm
Fort Worth (TX), Kimbell Art Museum

Though they have managed to crawl and totter to the stove, the skeletons find that both fire and lamp have gone out, quashing all hope for a little vital warmth. Ensor takes the figures' apparel and attributes as an opportunity to create a sophisticated play of colors and illumination.

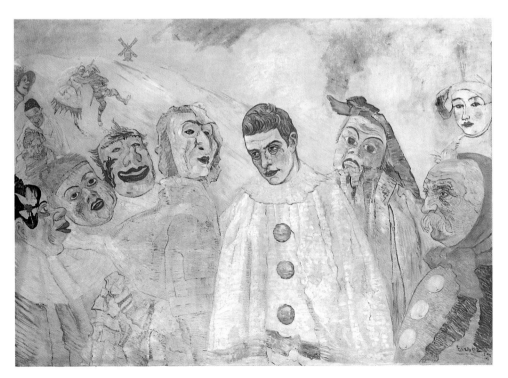

The Despair of Pierrot, 1892
Oil on canvas, 144.5 x 194.5 cm
Private collection

The pierrot figure resembles the young Ernest Rousseau and the bearded figure at the right his father, who seems to be calling his son to account for his practical joking; the figure in the green cloak might represent Mariette Rousseau. Possibly Ensor wished to express, anecdotally, his gratitude to the family who had welcomed him so cordially in Brussels.

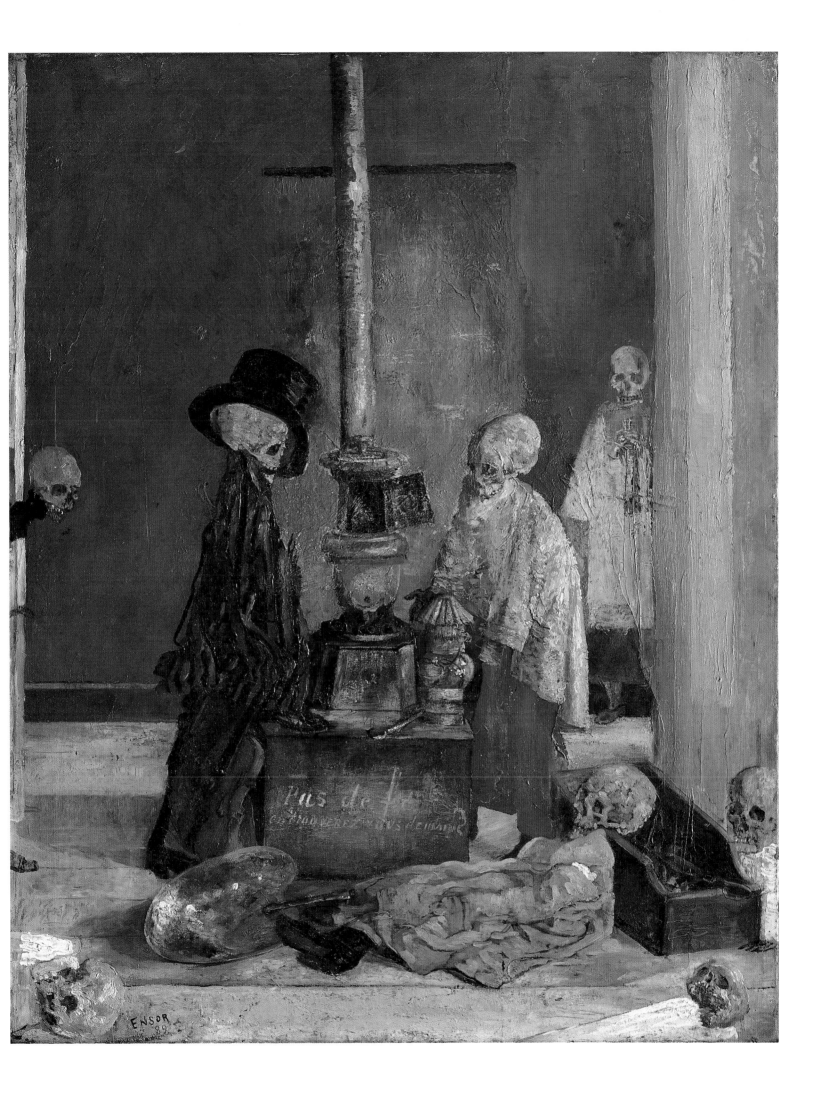

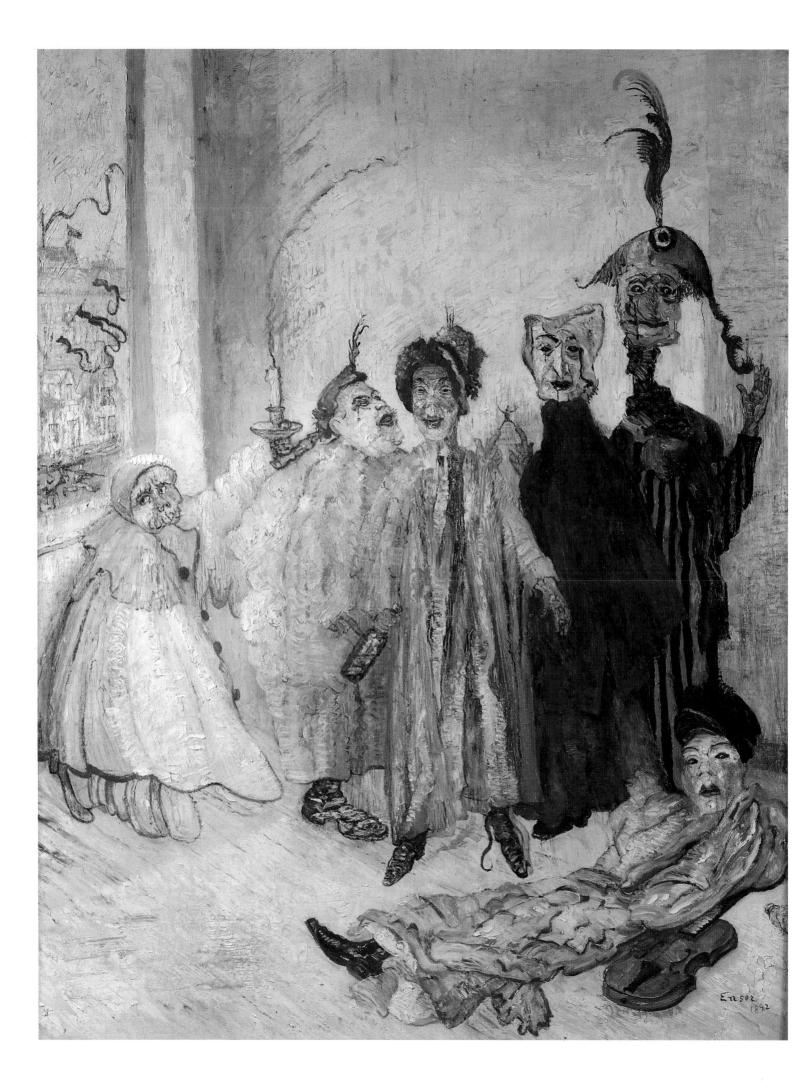

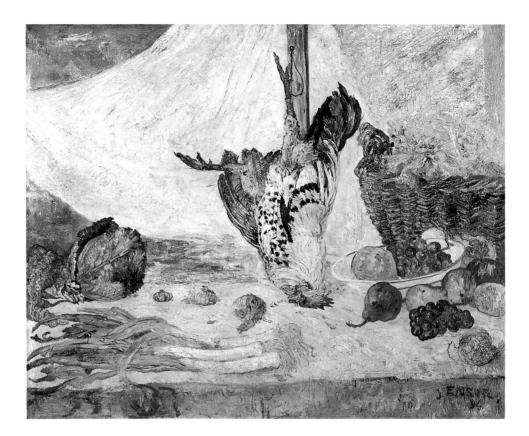

ABOVE LEFT:
Ensor (third from below) with friends, 1891

ABOVE RIGHT:
The Dead Cockerel, 1894
Oil on canvas, 80 x 100 cm
Mannheim, Städtische Kunsthalle

Here we see the artist consciously taking up the tradition of seventeenth-century Flemish still-life painting with its seemingly random combinations of objects of the most various kind.

PAGE 66:
The Strange Masks, 1892
Oil on canvas, 100 x 80 cm
Brussels, Musées royaux des Beaux-Arts de Belgique

This painting can be seen as counterpart and opposite pole to *The Scandalized Masks* of 1883. Its effect derives from an unreal, spiritualized atmosphere rendered in shimmering translucent color that recalls Whistler.
The party is over, the maskers return from the revels – laughable hollow papier maché figures who appear to consist of nothing but their costumes.

unusual motifs and stylistic inconsistency increasingly made him a marginal figure. They were more interested in Cézanne's open-air studies and van Gogh's symphonies in color. The lack of recognition for his work affected Ensor deeply, exacerbated his isolation, fostered distrust and anger.

High-strung and sensitive as he was, Ensor felt insulted when Octave Maus printed an exhaustive discussion of a work by Fernand Khnopff in *L'Art Moderne*. With hurt pride he wrote to Maus in September 1886, "You defend Khnopff so firmly. Solid bonds of friendship, presumably of a familiar kind, apparently unite you with him... The future will decide and accord to each the place he deserves... I have confidence in myself; the successes of others do not trouble me..." Ensor believed absolutely in his outstanding place among those Belgian artists, who, like him, turned against still flourishing academic and official art. Yet he remained entirely skeptical of the new directions, such as Symbolism and Neo-Impressionism, which had become established in France and England, the reason why Ensor thoroughly opposed accepting the American-born London artist James Abbot McNeill Whistler (1834–1903) into "Les Vingt." "Accepting Whistler," he exclaimed, "means walking into the arms of death... Once one has committed this thoughtlessness there will be no stopping. Then one would have to admit Rodin, Monet, Renoir, and even Puvis de Chavanne's and Moreau. [Whistler's] painting reeks of mould and mildew." The fact that a few of Ensor's own paintings (*Carnival on the Beach, Strange Masks*, p. 66) recall Whistler's poetic impressionism should be mentioned, if only in passing.

Though tensions grew between Ensor and "Les Vingt" and its founder Octave Maus, he continued to exhibit with the group on a regular basis. At the same time he became ever touchier, and ensconced himself ever deeper in the solitude of his atelier. He painted, drew or made etchings, and also produced a series of self-portraits in which he styled himself as a Rubens or Rembrandt, a Christ or St. Anthony, a skeleton striking a pose of victory, a beheaded or a crucified man – even as a fish or insect. Ensor was everywhere in Ensor. The changing, self-contradictory roles he assumed frequently reflect a mood of sarcasm and depression, though it is relieved by flashes of self-irony and humor.

The Ornamental Cabbage, 1894
Oil on canvas, 81 x 100 cm
Essen, Museum Folkwang

Again and again Ensor represented skeletons, a choice of subject perhaps less unusual in Ostend than elsewhere, for apparently it was no uncommon thing to find human skulls and bones in the area. In the course of a four-year siege of the town by Spanish troops in the early seventeenth century unnumbered people had died, and as Ostend expanded during Ensor's times, excavations continually runcovered their remains. Ensor reports that he was a youthful witness of the exhumation of an entire batallion, and was baffled by the nonchalant way in which his townsmen dealt with their grisly finds.

In addition to masks, the theme of death is ubiquitous in Ensor's paintings. He even represented himself as a skeleton in a few cases. An especially striking example of the motif is found in an etching of 1888 entitled *My Portrait in the Year 1960* (p. 73). In this look into the future the artist sees himself as a partly decomposed skeleton reclining on a divan, subject to the attention of a large spider crouching next to him. (Ensor had been afraid of spiders – and black birds, too – since his childhood. He had a particularly vivid memory of an "excursion" to the storeroom of his parents' house, in the course of which he discovered, amid the cobwebs, a cabinet full of rotting Carnival paraphernalia.) At any rate, *My Portrait in the Year 1960* evidently marks the overcoming of his revulsion, the end of the fight against his phobia – what a superb, self-ironic commentary on the part of the twenty-eight year old artist!

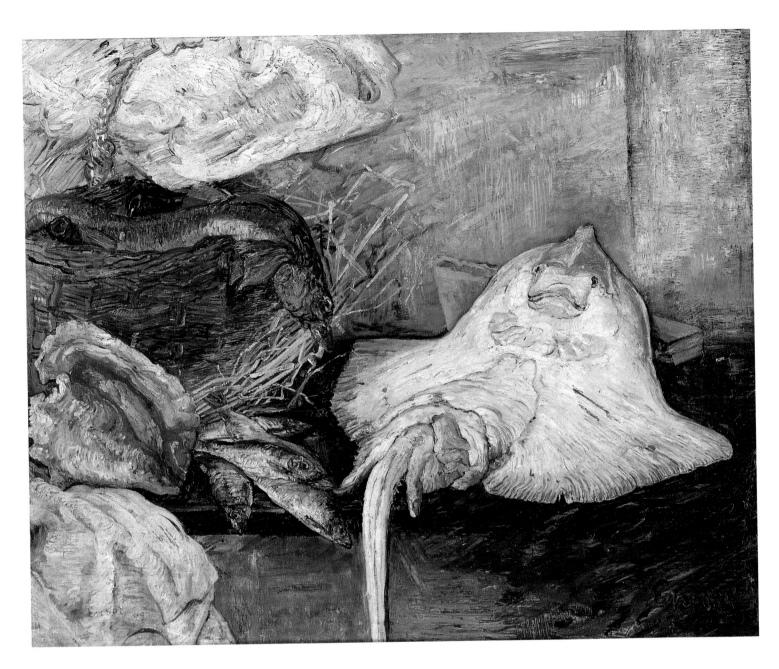

The Skate, 1892
Oil on wood panel, 80 x 100 cm
Brussels, Musées royaux des Beaux-Arts de
Belgique

Ensor's mastery of color and its nuances comes
out especially in still lifes such as this one. In
connection with the glowing pink opening of the
seashell, the skate might well have overtones of
erotic meaning.
An enigmatic passage is found on the left, where
two light-colored objects which seem to have no
solid place in the composition are depicted. The
upper object in particular is of a strangeness that
distantly recalls the surrealist motifs of Ensor's
countryman René Magritte.

A quite different mood suffuses the etching *My Portrait as a Skeleton*, (1889,
p. 71). Here the artist reworked a plate on which he had depicted himself in fair-
ly "normal" terms. The point of departure was again a photograph, this time one
taken of Ensor in the Rousseau house in Brussels. *My Portrait as a Skeleton*
evinces a highly disquieting combination of opposite states of mind typical of
the artist: triumph and a sense of martyrdom. If the public did not yet under-
stand him and made his life a continual torment, he seems to say, someday the
value of his work is bound to be recognized; victory over ignorance and stupid-
ity is assured. As in the etching *My Portrait in the Year 1960* Ensor has retained
the curly locks of which he was so proud – apparently in an ironic commentary
on the transitory nature of fame.

In the painting *Death and the Masks*, 1897, similarly to *The Intrigue*, Ensor
depicts a group of figures. This time, however, he places the figure of Death in
the middle, surrounded by masqueraders who appear to press in on him. Death
holds a candle with guttering flame, symbol of the lamp of life. In the sky, two
grim reapers pursue a balloonist who jettisons ballast in an attempt to escape
them. A remarkable feature of this painting is the distribution of red, white and
blue tones, which dominate the composition. The expanse of red in the lower left
corner is echoed in the red hat frill at the right; the hatched blue area at the lower
right rhymes with the blue field of sky at the upper left. These diagonally placed

color correspondences serve to frame the white shroud of the figure of Death which dominates the center and from which white, billowing clouds rise into the sky, drawing the eye to the red balloon.

Unlike his Symbolist contemporaries, such as Gustave Moreau (1826–1898), Arnold Böcklin (1827–1901), and especially Fernand Khnopff (1858–1921), Ensor rarely brings the morbid aspects of the theme of death into play. His depictions of death are many-facetted, ambiguously oscillating between allegory and parody. the fear of mortality may be treated as an illusion, especially when evoked in combination with the mirror motif; or, when embodied in a grotesque figure, it may be made to look ridiculous or just the opposite, an omnipresent and omnipotent demonic principle.

However, *My Portrait as a Skeleton* is a different case entirely. Here Ensor worked in several stages from the initial photograph, to an etched self-portrait, to a self-portrait as a skeletal deathmask. The artist's identification with the figure of death is complete, without hint of the irony or insouciance characteristic of his usual treatments of death.

With the death of his father in 1887 Ensor lost the only member of his family to appreciate his artistic activity. Suddenly death became glaringly real, embodied in an actual, personal experience. From this time on related motifs began to dominate his work as never before. Appearing in various guises in the abandonment of the Carnival of the world, death became an ever-present threat.

Death and the Masks, 1897
Oil on canvas, 78.5 x 100 cm
Liège, Musée d'Art moderne et d'Art contemporain de la Ville de Liège

Death mingles among the revelers at a Carnival celebration. The composition is dominated by strong, pure primary colors, in sharp contrast to the white shroud of Death and his halo of clouds. In the sky, too, death reigns, in the form of two grim reapers pursuing a balloonist.

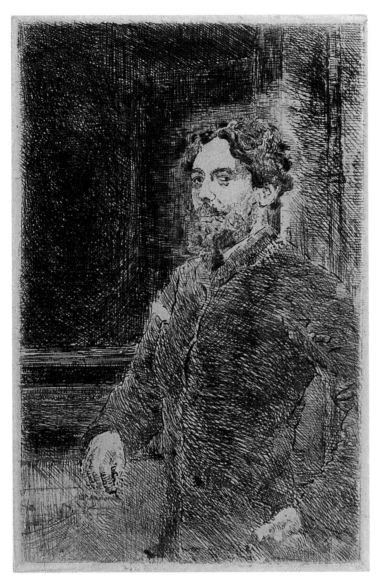

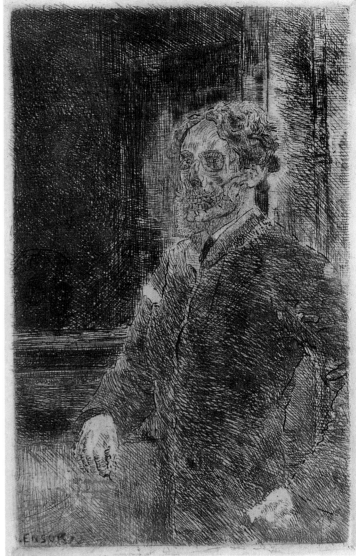

Self-portrait, 1889
Etching on parchment, 11.6 x 7.5 cm
Ostend, Museum voor Schone Kunsten

The image was based on a photograph of Ensor
made at the Rousseaus' in Brussels. In this first
state of the etching Ensor still appears with "nor-
mal" facial features.
In the course of developing the etching the artist
progressively "flayed" his face and represented
himself as Death in a pose of victory.

My Portrait as a Skeleton, 1889
Etching on hand-made paper, 11.6 x 7.5 cm
Ostend, Museum voor Schone Kunsten

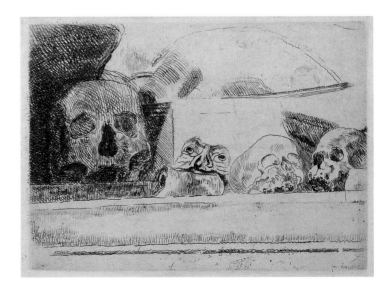

BELOW RIGHT:
Skulls and Masks, 1888
Etching on Japan, 9.1 x 12.9 cm
Slijpe (Belgium), James Ensor Archief,
P. Florizoone

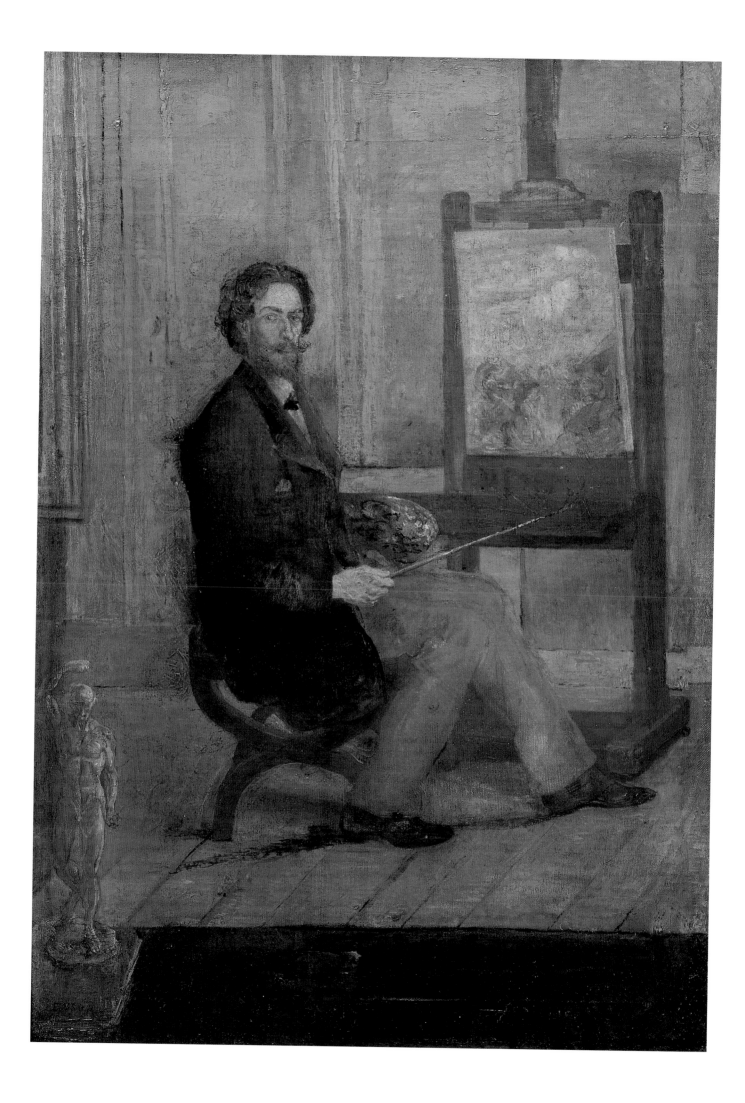

Hareng Saur – Satire and Caricature

In the year 1893 in Brussels, the tenth and final exhibition of "Les Vingt" took place, Octave Maus having been able to convince the others that avant-garde groups, to remain effective, must not be allowed to exist too long. Ten years, he felt, were enough. Maus then proceeded to announce, for 1894, the founding of a new group, to be named "La Libre Esthétique." Ensor vehemently resisted the disbanding of "Les Vingt," it being his most important link with the public. But he was outvoted by the other members of the group – or he may not even have been invited to the decisive session. At the final exhibition Ensor was nevertheless the most discussed painter of "Les Vingt." The journal *L'Art Moderne* reports that "His art is becoming more energetic and untamed, and more inexorable. The grotesque-caricatural traits come to the fore, and the colors live through bright white and red and blue tones of a purity that compellingly draws the eye."

Although he participated in the exhibitions of "La Libre Esthétique," Ensor went in the 1890s through a profound creative crisis, was racked with self-doubt and lost faith in the worth of his art. In this phase of depression he even went so far as to put up for sale his studio and its entire contents of pictures for the sum of 8000 francs. Despite considerable efforts, no purchaser was found. On the advice of his mother, Ensor lowered the asking price; yet still no one was interested.

In the course of his career Ensor created numbers of self-portraits which provide insight into his state of mind and attitude to his artistic calling and skills. In one of these self-portraits, done in the year 1890, we see the artist seated before the easel in his studio, in an upright, distinguished pose. The way he gazes into the mirror, self-assured and aloof, is very much the same as in the earlier self-portraits. The hand holding an extremely long brush points toward the painting on the easel. Although on first glance this portrait recalls atelier depictions of the traditional type, its composition, illumination, and palette lend it a special place within Ensor's series of self-portraits.

It is another good example of the way Ensor assumes a role, like an actor on stage, as we have already seen in *Ensor with a Flowered Hat* (p. 9). The poise he exhibits, and the calm, dignified mood of the atelier scene as a whole, have little to do with the actual situation that obtained in the attic room of his parents' house. Ensor presents himself here as a self-confident "artist-prince." The studio is pervaded by an imaginary, golden brown light, and there is seemingly a second source of illumination concentrated on the head and hand of the artist and the picture on the easel, lending them special emphasis. The picture represents a landscape with a group of figures in the foreground, in whose midst there is apparently a figure of Christ in a bright nimbus. The colors of the nimbus are repeated in slightly different gradations on the head and back of the artist. This analogy illustrates, yet again, Ensor's affinity and identification with Christ, if in this case in a much more indirect, encoded way than in *The Entry of Christ into Brussels*.

My Portrait in the Year 1960, 1888
Etching on wove, 6.4 x 11.4 cm
Brussells, Collection Crédit Communal – Dexia

PAGE 72:
Ensor at his Easel, 1890
Oil on canvas, 59.5 x 41 cm
Antwerp, Koninklijk Museum voor Schone Kunsten

Like so many of his self-portraits, this one reveals Ensor's search for an artistic identity. In the reference to Christ (the vaguely recognizable figure in the painting on the easel), the symbolistic color scheme, and the specific treatment of the pictorial space, he shows himself to be an painter of fantasy worlds who suffered more from the criticism of his contemporaries than the proud, obstinate expression of his face would indicate.

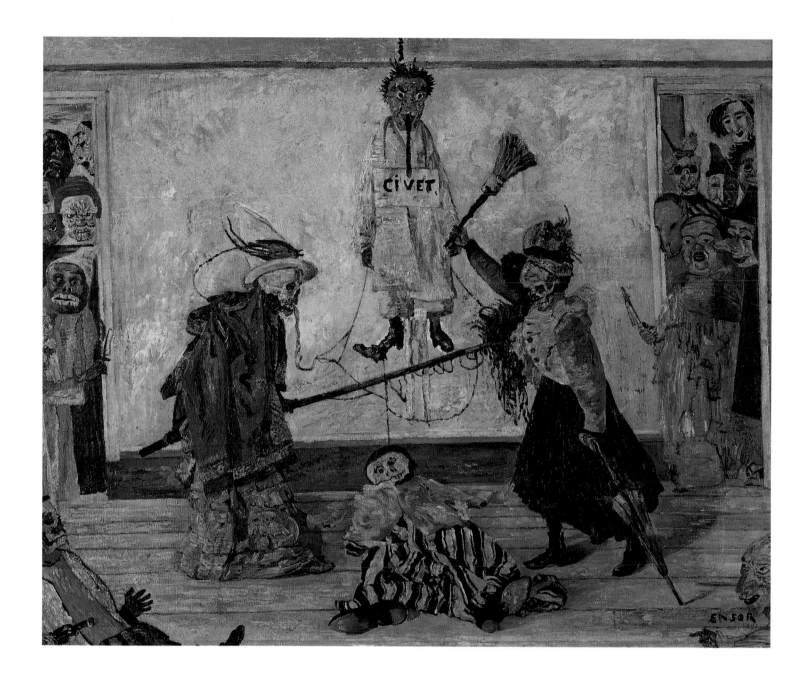

The composition of the painting is extremely complex. It contains a number of pictorial elements that cannot be definitely placed within the real space represented. What are we to make, for instance, of that dark zone at the lower edge that seems to disturb the coherence of the spatial situation? Does this dark band, which continues in narrower form up the left edge of the canvas, belong to the mirror in which the artist observes himself? And what piece of furniture, if it is one, serves to support the figurine, actually an articulated clay figure rendered as if it were translucent? Is it a mirror frame? What function does this translucent figure serve, as it apparently has so little connection with the main motif of an "artist seated at the easel," and itself seems so strangely removed? Usually such figures were used in the context of life-drawing classes at the academy. So we may assume that in this self-portrait Ensor addresses the theme of the incompatibility of academic art and artistic freedom, and wishes to illustrate for the viewer the opposition between painting conventions and untrammelled, intuitive imagination.

Such a seemingly conventional picture as this self-portrait stands only on first glance, with regard to its genre, in contrast to the subject matter to which Ensor now began increasingly to turn. As an artist he was a pluralist in terms of painting type, style, and genre. What most concerned him was not consistency but the

Masks Fighting over a Hanged Man, 1891
Oil on canvas, 59 x 74 cm
Antwerp, Koninklijk Museum voor Schone Kunsten

What ludicrous event is this, taking place before the eyes of a grinning audience? Some commentators assume that the painting was adapted from a photograph showing Ensor and his friend Ernest Rousseau, Jr., playfully arguing with each other in the dunes at Ostend (see. p. 94).

PAGE 75 ABOVE:
Ensor and General Leman Discussing Painting, 1890
India ink, pencil, and colored pencil on paper, 12 x 17.5 cm. Private collection

PAGE 75 BELOW:
Demons Teasing Me, 1895
Relief engraving on paper, 11.4 x 15.4 cm
Ostend, Museum voor Schone Kunsten

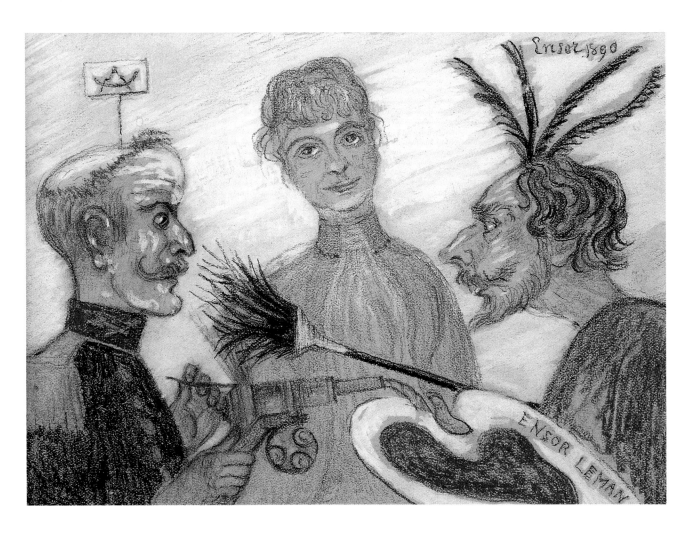

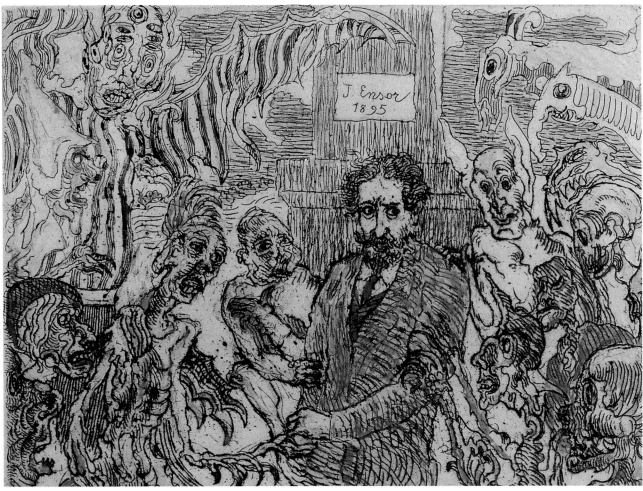

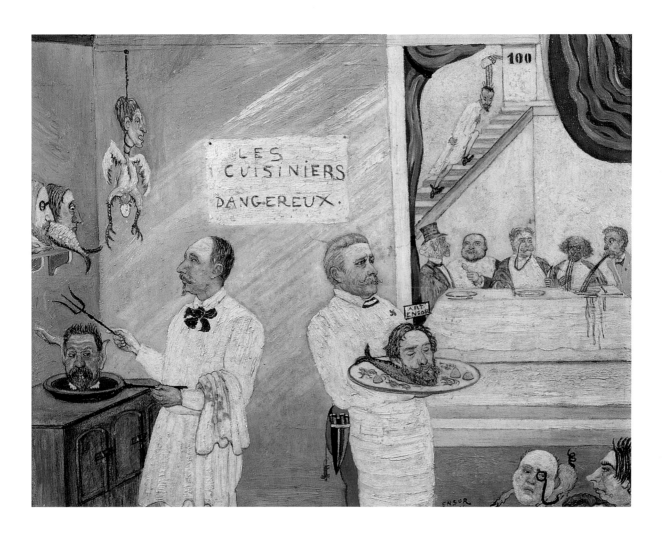

Skeletons Fighting Over a Pickled Herring, 1891
Oil on wood panel, 16 x 21 cm
Brussels, Musées royaux des Beaux-Arts de Belgique

A play on the assonant French phrases "Hareng Saur" (smoked pickled herring) and "Art Ensor". The herring stands metaphorically for the artist being, as it were, torn to pieces by his critics.

PAGE 76 ABOVE:
The Dangerous Cooks, 1896
Oil on wood panel, 38 x 46 cm
Private collection

PAGE 76 BELOW:
The Grotesque Singers, 1891
Oil on wood panel, 16 x 21 cm
Private collection

expression of his attitude to the world around him through free, creative activity, and whether this involved making a still life, self-portrait, or caricature was entirely secondary. Every genre and technique appeared suitable in one or the other form to couch his personal and complex views on artistic, social, or political subjects that concerned him.

In the early 1890s Ensor developed a style that was more graphic and narrative than before, which he used, as it were, to tell stories of an often grotesque or macabre turn. *Skeletons Fighting for the Body of a Hanged Man* (p. 74) is a case in point. With a great mastery of composition and compelling play of color, Ensor shows us a ridiculous battle taking place between two ragged figures in eerily funny costumes. It has been suggested that the painting was based on a photograph showing Ensor and his friend Ernest Rousseau, Jr., playing with bones and parts of skeletons in the dunes. Possibly, however, the painting was done first and then staged as a tableaux for the camera by the two friends.

Many artists of the past provided inspiration for Ensor's satirical drawings and paintings, such as the English caricaturists William Hogarth (1697–1764), Thomas Rowlandson (1756–1827), and James Gillray (1757–1815), whose works were widely published at the end of the nineteenth century and were extremely popular on the Continent as well. In a letter to the critic Pol de Mont on October 4, 1900, Ensor wrote: "I am English by birth and have family in England. I addition, my art bears an undeniable resemblance to English art – the real stuff – my etchings as well as my landscapes, and it would be greatly to my advantage for my work to be known in England. It would be quite difficult to choose which

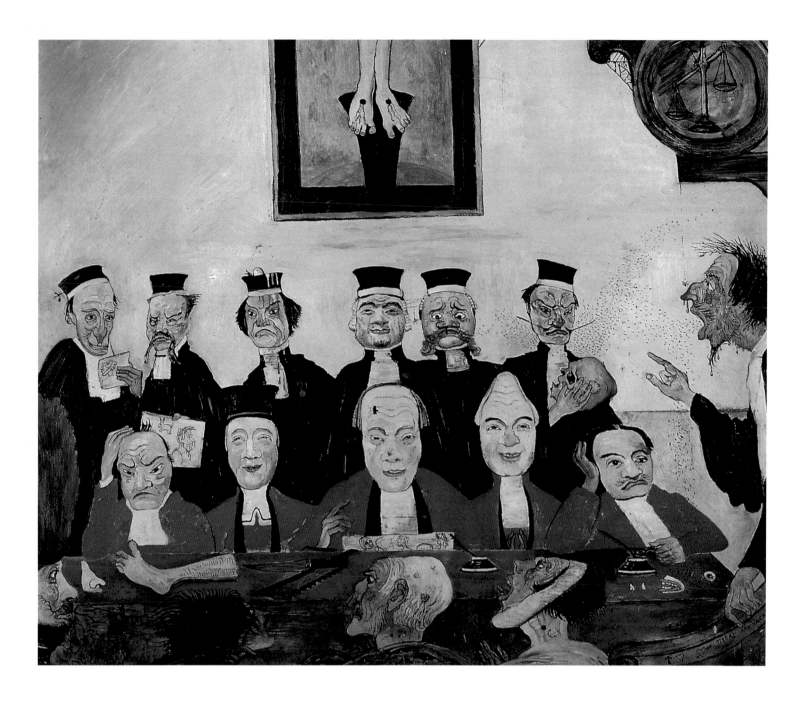

The Wise Judges, 1891
Oil on wood panel, 38 x 46 cm
Private collection

Ensor's weapon was caricature, and the driving force behind it was an anarchistic spirit, irony, and scorn. The judges are wise only in their own eyes, he seems to say, and certainly incapable of judiciously deciding this difficult case: "My favorite pastime is depicting other people, distorting them, embellishing them."

work to reproduce there because the taste of some of the English artists of today is extraordinarily perverted. Under the influence of the work of Botticelli, the majority of today's artists turn their noses up utterly at the great masters and satirists like Turner, Constable, Crome, Gainsborough, Hogarth, Rowlandson etc. Do you not agree with me, Monsieur De Mont, that my vision, my style and my painterly qualities give me something in common with these artists, in landscape painting as well as in satire? I feel more English than most of the English artists now slavishly imitating the early Italians. That might be a point to stress. A reaction is bound to set in soon. For the rest, you have highlighted the English character of my works to perfection."

At this juncture it would be good to recall the tragicomic nature of Ensor's personality, which led his friends to call him "Pierrot la Mort" (Pierrot of Death). Ensor used proudly to demonstrate his ability to play a flute with his nose, he and his friend Ernest Rousseau dressed up in bizarre costumes and staged dramatic scenes in the dunes, he wrote texts of an almost Dadaist flavor – for instance, on his time at the academy or about women – and loved foolishness and nonsense of every sort. A popular pastime among men of Ensor's age, especially in Brussels, was something called "zwanze," a kind of risibly comic,

mocking soapbox speech that, like the Dada nonsense it anticipated, was often triggered by no more than an exuberant spirit of fun.

In his paintings Ensor frequently turned a scornful eye on the pillars of bourgeois society, such as judges, doctors, and clergymen. He mocked them in his caricatures, pillorying their hypocrisy, stupidity, and enviousness. His humor was acid and macabre, occasionally, if truth be told, revolting. He had no scruples about depicting the basic, if unmentionable or euphemized, bodily functions such as farting, pissing, belching, vomiting, and this drew harsh criticism, even from his friends. Eugène Demolder, one of his closest companions in the Brussels circle around Rousseau and his wife, wrote to Ensor from Paris: "Your caricatures are not at all appreciated. People find them puerile and common."

A frequent theme of his satirical work is Ensor himself in the role of neglected, misunderstood artist fighting single-handed for the liberation of art. An example is the canvas *Ensor and Leman Discussing Painting* (p. 75), where the artist wields his frayed brush like a sword. His opponent is armed with a toy cannon, but to no avail. In the middle of the scene sits Mariette Rousseau, as arbitrator or judge. In this caricature Ensor explicitly refers to the attacks that were being mounted on his art. The critic is an antagonist decorated with a laurel wreath who acts in the name of order and decency; Ensor himself, adorned with feathers, is depicted as a free, imaginatively gifted man. Once again he shows the degree of wit and self-irony of which he is capable.

The Bad Doctors, 1892
Oil on wood panel, 50 x 61 cm
Brussels, Université Libre de Bruxelles

Ensor's negative attitude toward politicians and clergymen, doctors and judges found expression in a series of acid caricatures. In *The Bad Doctors* he pokes fun at the profession of medicine, whose representatives are depicted as assiduous but incompetent fools.

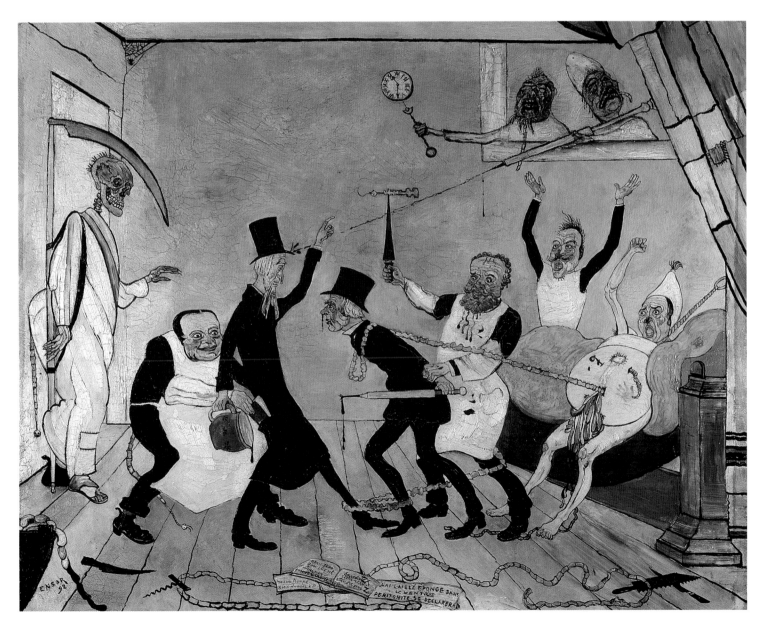

Ecce Homo (Christ and the Critics), 1891
Oil on wood panel, 12 x 16 cm
Private collection

Here Ensor depicted himself as the suffering
Christ, derided by the men he considered his true
enemies, the critics Edouard Fétis and Max Sulz-
berger.

The Virgin of the Consolation, 1892
Oil on wood panel, 40 x 38 cm
Private collection

The artist in the role of a humble adept of
painting, kneeling and supplicating the Virgin
for divine – that is, artistic – inspiration.

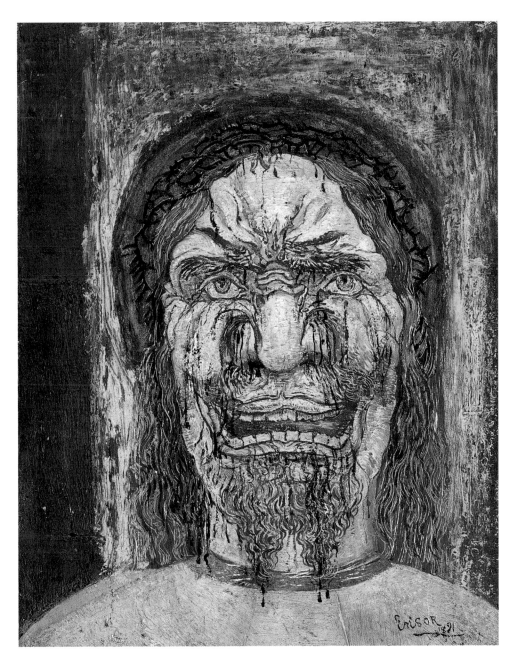

The Man of Sorrows, 1892
Oil on wood panel, 21.5 x 16 cm
Antwerp, Koninklijk Museum voor Schone
Kunsten

The tormented face of Christ reflects the pro-
found existential crisis that the artist went
through in the early 1890s. In this phase of
depression he even went so far as to put up his
studio and its entire contents of pictures for sale.
Despite considerable efforts, no purchaser was
found

Yet Ensor goes even farther in satirizing his own role of misunderstood artist.
In *Skeletons Fighting Over a Pickled Herring* (p. 77), the focus of the composi-
tion is the fish, known in Belgium as a "hareng saur." Now, when spoken, the
words "Hareng Saur" have a similar sound to "Art Ensor," so what we have are
two skeletal critics fighting over Ensor's art and pulling it to pieces in the pro-
cess. The depiction, in which the drawing and its critical content enter a harmo-
nious unity with the quite lyrical colors of the ground, goes far beyond mere
caricature. It is further proof of Ensor's amazing originality, which has lost none
of its force even today. Stylistic unconventionality and an extraordinary force of
imagination enabled Ensor to create imagery whose range of meaning and wit
still remain to be discovered.

Fantasies of a quite different sort, less drastic and more in a narrative mode
are seen in the sarcastically humorous composition *The Dangerous Cooks*
(p. 77), a parody on the artists' dinners which were so popular at the time. Here,
too, the painter – in the company of other Belgian artists and members of "Les
Vingt" – depicts himself as a victim of persecution, slander, and ignorance. This
time his head lies on a plate, and next to it, again, is a pickled herring and a
placard reading "Art Ensor." This "pièce de résistance" is being presented to the
company by Octave Maus, co-founder of "Les Vingt" and La Libre Esthètique.

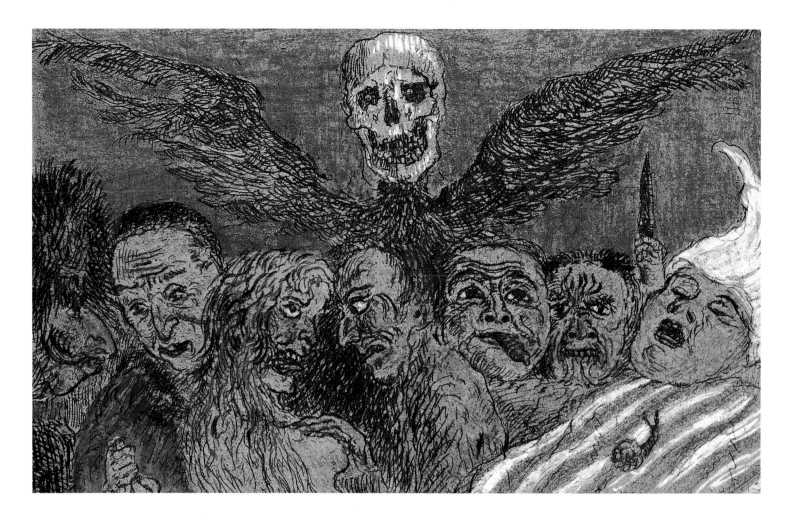

The second "dangerous cook" is Edmond Picard, a well-known attorney and editor of the journal *L'Art Moderne*. The two were considered the most influential men in the Belgian avant-garde. The guests at the feast are (from left to right) the critics Edouard Fétis, Eugène Demolder, Camille Lemmonier, Max Sulzberger, and Emile Verhaeren, Ensor's friend and admirer, who is spitting on Sulzberger's plate.

In *Ecce Homo, (Christ and His Critics)* (p. 80 above) Ensor represents himself in a martyr's pose, flanked by his worst opponents, Sulzberger (right) and Fétis (left). Here the reference to the Passion of Christ – in the figure of the artist with crown of thorns, rope, and mock scepter – is taken to extremes. The identity of the henchmen, Fétis with the same disapproving expression as in *The Dangerous Cooks*, Sulzberger baring his teeth, and both clad in top hat and tails, underscores the relevance of this caricatural composition to the current art scene.

Not only in his choice of subjects but in his painting technique as well, Ensor exhibited an amazing inventiveness and experimental audacity. In his search for ways to adequately express his ideas, he combined diverse styles and employed a great range of techniques. He painted on canvas, wood, paper and cardboard, and not only used oils and watercolors, chalks and colored pencils, but mixed these media in quite free and unconventional ways. Ensor worked with both palette knife and extremely fine brushes, sometimes even resorting to a broad spatula, as in *The Entry of Christ into Brussels*. When we look at Ensor, we must be prepared for anything, in every respect. "Each new work should evince a new procedure," he wrote in a letter to André de Ridder.

This stylistic pluralism has already been met with in many of the paintings discussed. It becomes particularly striking in two thematically and stylistically quite different works from the early 1890s, *The Man of Sorrows* (p. 81) and *The Virgin of the Consolation* (p. 80). The face of *The Man of Sorrows*, rendered in

The Deadly Sins Dominated by Death, 1904
Etching on Japan, heightened with white gouache, watercolor, and colored pencils, 8.4 x 13.4 cm
Slijpe (Belgium), James Ensor Archief,
P. Florizoone

This was the frontispiece to a series of *Seven Deadly Sins* published by Eugène Demolder in 1904. It shows Death extending his wings over figures embodying the mortal sins (left to right): pride, avarice, wrath, lust, gluttony, envy, and sloth.

thick, irregularly applied impasto, is deeply scored with incised lines of great expressive power which compellingly convey both pain and anger. On a blood-red ground Ensor renders an unutterably distorted and convulsed face full of naked fury and suffering. Every reconciliatory aspect is avoided; his Man of Sorrows is nothing less than a sign of a profound moral crisis. Ensor suffered, whether he was painting or not. To the critic Dujardin he wrote, "For me as well, art is born of pain and except in rare instances my life is bound up with bitterness and disillusions."

The Virgin of the Consolation, in contrast, is pervaded by a serene, well-nigh lyrical mood. In a style reminiscent of the Symbolism of a Fernand Khnopff or an Edward Burne-Jones (1833–1898) Ensor shows an entirely different side of his nature, the humbleness of an artist in face of the Virgin, an allegory of painting. Here he hopes for consolation - that is, inspiration and spiritual nourishment. The picture is rendered in a decorative, flat manner; most of the objects and figures are brought into play by means of linear contours.

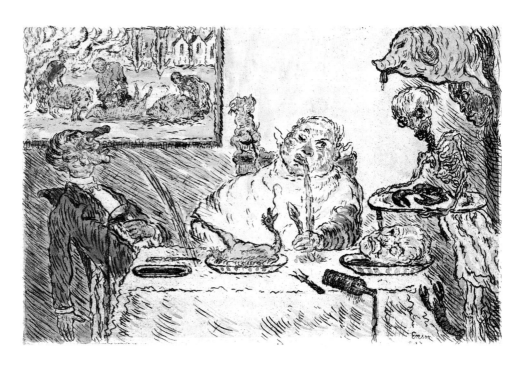

Gluttony, 1904
Etching on Japan, heightened with watercolor and colored pencils, 9.1 x 14.5 cm
Ostend, Museum voor Schone Kunsten

One of Ensor's sequence of etchings treating the theme of human vices in a satirically and grotesquely exaggerated manner.

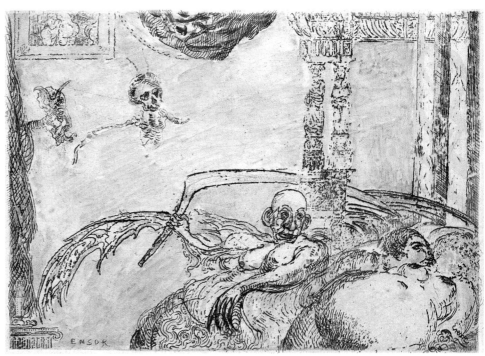

Lust, 1888
Etching on Japan, heightened with watercolor and colored pencils, 9.2 x 13.1 cm
Ostend, Museum voor Schone Kunsten

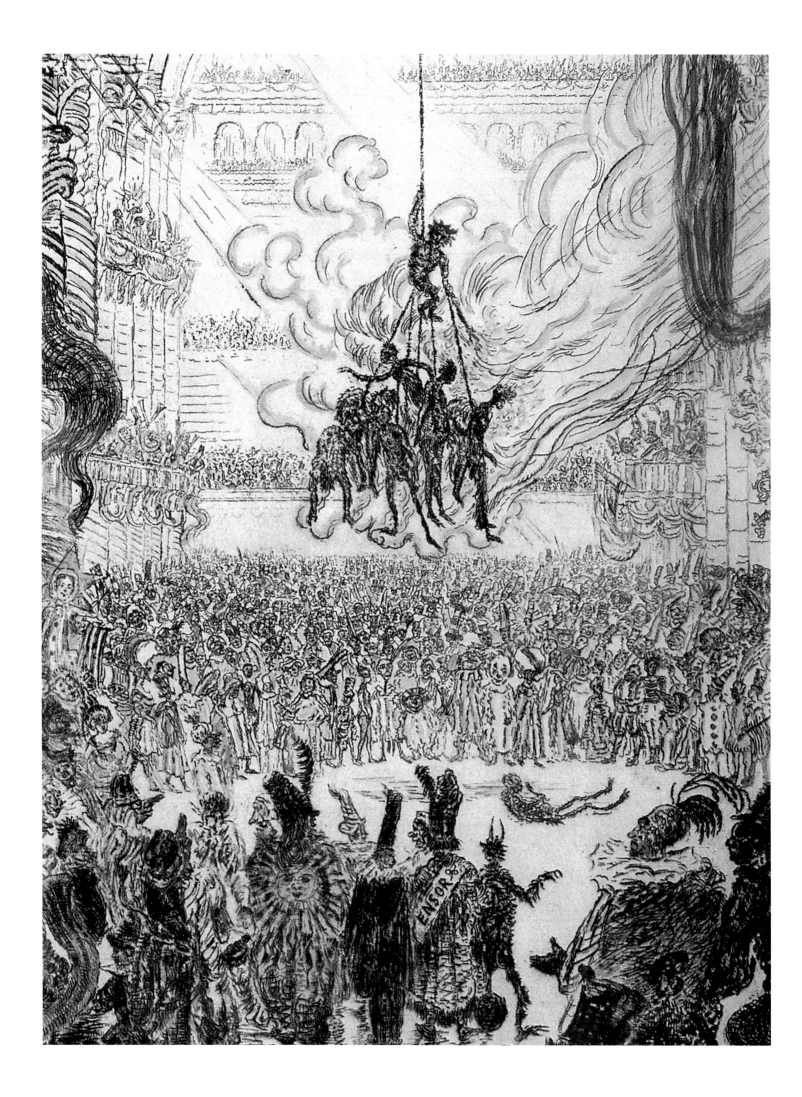

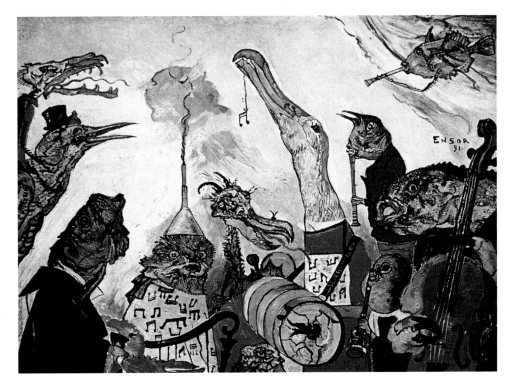

The Frightful Musicians, 1891
Oil on wood panel, 16 x 21 cm
Private collection

A fantastic assembly of bizarre and eerie human-animal hybrids worthy of a Bosch or Brueghel. One senses the glee with which Ensor invented these scurrilous creatures playing a wild caco-phonous dance on their instruments.

PAGE 84:
Hop-Frog's Revenge, 1898
Etching on Japan, heightened with watercolor,
35.4 x 24.5 cm
Collection Mira Jacob, Paris

This etching was inspired by a tale of Edgar Allan Poe's. The theme (the mask of an outlaw) was especially suited to Ensor's state of mind. As in *The Cathedral* he succeeds in depicting people in the mass as a single, composite element.

Ensor is justly considered one of the most versatile artists of his day: at times bitter, at times humorous, anxious and aggressive in equal degree, but also sensitive and ever-ready to mock, qualities that put an inimitable stamp on his work. The incredible range of his means of expression becomes especially obvious in his graphic art. In the more than one hundred etchings made from 1886 onwards Ensor addressed subjects of the most diverse kind: landscapes, still lifes, stories from the Evangelists, portraits, fantastic sceneries. His most significant etchings emerged in the course of only three years; after 1896 he abandoned the technique and would rarely return to it later. In this connection Ensor frequently quoted or adapted already existing paintings, but also proceeded vice versa, translating etchings into oil paintings.

At times Ensor took his inspiration from literature as well. The drawing *The Devil in the Belfry* or the etching *Hop-Frog's Revenge* (p. 84) were based on literary sources, the latter on the tale "Hop-Frog" by Edgar Allan Poe, whose uncanny and horrifying theme intrigued Ensor. Poe had exploited the fantastic potential of a report by Froissart on an incident that took place during a masquerade ball held at the court of King Charles VI of France. A dwarf jester, tormented by courtiers, takes revenge by convincing them to dress for a masquerade ball as orangutans, in costumes of tar and feathers. He fastens himself and them by a chain to the hook of a chandelier, which is then pulled up to the ceiling. Pretending to want to get a better view of the king, who is also among the masqueraders, Hop-Frog holds a torch to the "flaxen coat" that enveloped them, which "instantly burst into a sheet of vivid flame. In less than half a minute the whole eight ourang-outangs were blazing fiercely, amid the shrieks of the multitude who gazed at them from below, horror-stricken, and without the power to render them the slightest assistance.... 'I am simply Hop-Frog, the jester – and this is my last jes'," cried the dwarf, "...hurled his torch at them, clambered leisurely to the ceiling, and disappeared through the sky-light" (E. A. Poe, "Hop-Frog").

Ensor was evidently fascinated by Poe's adaptation of the historical occurrence, both by the motif of a crowd of masqueraders looking helplessly on as the gruesome spectacle unfolded and by the revenge taken by the insulted dwarf on his tormentors, a situation which bore definite parallels to his own.

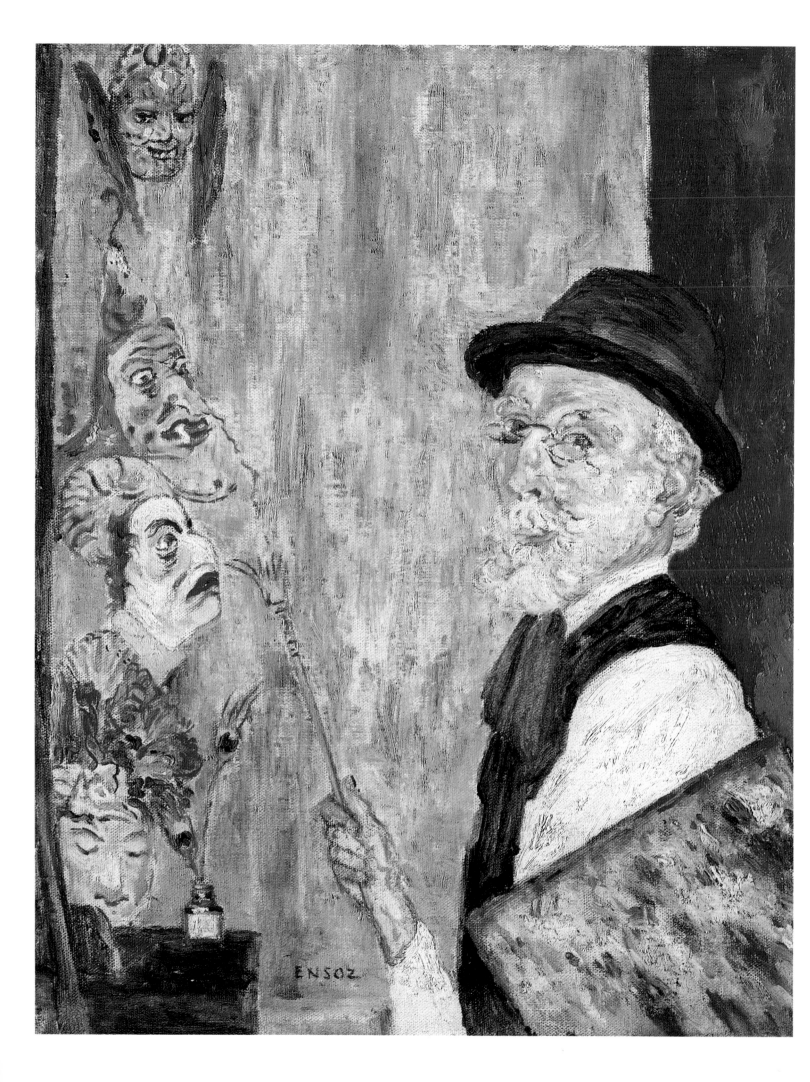

Baron Ensor – Late Fame

Shortly before the turn of the century James Ensor came more strongly into the public eye on account of three events. In 1895–96 Eugène Demolder mounted Ensor's first one-man exhibition in Brussels; that same year the Musées Royaux des Beaux Arts in Brussels acquired *The Lamp Boy* (p. 19); and in 1898, a special issue of the French avant-garde journal *La Plume* devoted solely to Ensor was published.

Up to this point the Ostend painter had sold only a very few pictures; his painting offered no financial security. Even at the age of almost forty, he still remained dependent upon his mother's income. Only the Rousseaus occasionally purchased a painting to encourage him. His more recent, aggressively disquieting work was not appreciated by audiences at all. It is indicative that when the Brussels Royal Museum decided to acquire an Ensor, it was a traditional work from the milder, early period, The *Lamp Boy*.

Ensor's financial situation did not change until 1904, when the author Emma Lambotte (1878–1963) noticed him and bought numerous works. She also brought him into contact with François Franck, an Antwerp businessman and founder of the journal *Art Contemporain*, who became an ardent admirer of Ensor and collector of his paintings. Works from the Franck collection eventually laid the foundation for today's superb Ensor department at the Antwerp Museum of Fine Arts.

Around the year 1896 the artist depicted himself as a skeleton at the easel, on which a tiny picture stands. The composition is painted in sulfur-yellow and bluish-green hues heightened with white, and goes back to a photograph of the same year showing Ensor seated at his easel, surrounded by his paintings, etchings, and drawings. For Ensor – as for numerous other artists of the period – working from photographs was a not uncommon procedure; many of the later self-portraits in particular were based on photographs. The fact that he styles himself a skeleton in this case lends the scene both an ironic and a tragic aspect, a dead man of course being liberated from all fears and obsessions. Painting, the artist seems to say, is the only thing in life that holds meaning for him, and the fear of failure and a loss of creativity is always there just under the surface. "I am 26 years old," Ensor had already written ten years previously, "I am not happy. Thoughts of survival frighten me. The transitoriness of the painting material gives me cause for worry."

After the turn of the century Ensor toned down the bright colors, the as it were Fauvist palette that had characterized the mask paintings above all. The colors grew more subdued and less dramatically expressive; his paintings now began to evince a well-nigh lyrical coloration that recalled the earlier phases. Evidently Ensor had begun to look back and to return to themes treated in previous work, depicting them again, in lighter tones. Since he was reluctant to part with works done in the 1880s and 1890s, in which interest was increasing, he started, sometimes voluntarily, sometimes on the spur of a commission, to make

Ensor seated at the harmonium, 1940

PAGE 86:
Self-Portrait with Masks, 1937
Oil on canvas, 31 x 24.5 cm
Philadelphia (PA), Philadelphia Museum of Art,
The Louis E. Stern Collection

"This old painter discomfits us, he rides his hobby horse, he vaults, he flutters like a butterfly, he sniffs around, he bombards us with sharp arrows, delivers bites left and right, he's rascally, a meeowing joker, rather malicious, and occasionally resorts to satire," Ensor described himself in the year 1931.
In truth he was "an old man, gone grey under his helmet" (Ensor), whose palette seems to slip out of his grasp. He wields the brush like a spear, pointing a bit wistfully to the bizarre imaginative creations of his youth.

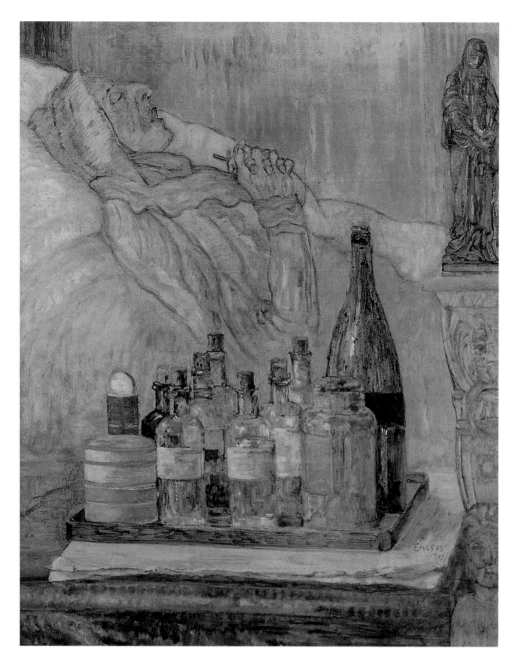

The Artist's Mother in Death, 1915
Oil on canvas, 75 x 60 cm
Ostend, Museum voor Schone Kunsten

Ensor made at least four depictions of his mother on her deathbed. In the present version her figure appears in the background, behind a tray filled with medicine bottles. This dominant foreground motif, in which the effects of light are rendered in marvellously nuanced color, becomes a beautiful still life in its own right.

copies of earlier works (e.g., *The Oyster-Eater*, p. 29; *The Tribulations of St. Anthony*, p. 36/37; *The Bourgeois Salon*, p. 17). Francine-Claire Legrand has described the change that occurred in the late Ensor as a transition from an heroic, rebellious "Don Quixote tilting against windmills" to a rather "sad and ironic Pierrot." *Self-Portrait with Masks* of 1937 (p. 90) shows the artist as a kindly old man who is involved in a tongue-in-cheek conspiracy with the figments of his imagination.

The passionate and uncompromising stance vanished from Ensor's works, yet always the sharp-eyed observer of social injustices and dubious developments in his environment, the artist could become an outspoken critic when it was a matter of attacking abuses. When a discussion about the protection of animals began in Belgium, for instance, Ensor reacted to the cruelty of the experiments being performed on them with a painting, *The Vile Vivisectors* (p. 90). Recurring to his repertoire of masks, skeletons, and grotesque figures, he commented in a deeply sarcastic and revealing way on what live frogs and dogs were made to suffer in the name of zoological and medical advance. At the left of the picture appears a (corruptible) clergyman with a bird in process of defecation on his head and a glorious peacock gracing his surplice. Here Ensor vents his anger at the church for not taking a firm stand on vivisection. When in 1929 an animal protection

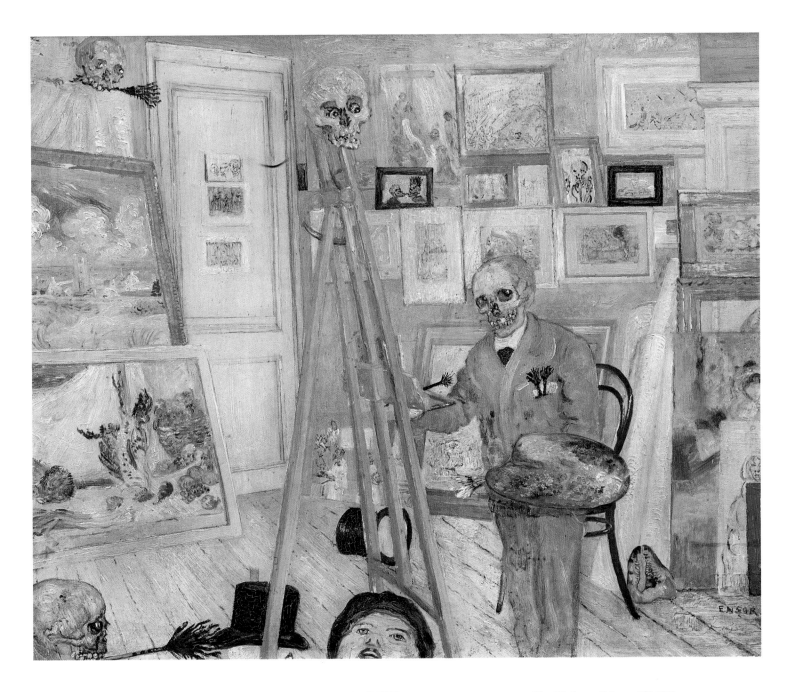

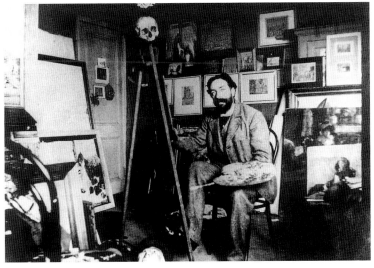

Ensor in his studio, c. 1897

The Skeleton Painter, 1896/97
Oil on wood panel, 37.5 x 45.5 cm
Antwerp, Koninklijk Museum voor Schone
Kunsten

In toxic yellow illumination Ensor depicts him-
self with an array of his paintings as a skeletal
artist with frayed brushes, working on a tiny can-
vas on the easel. The hunched shoulders and
doubting gaze, so unlike the self-confident artist
in the photograph on which the painting was
based, seem to illustrate Ensor's fear of a decline
in creative powers.

IMFÂMES VIVISECTEURS
JE VOUS CRACHE TOUT
MON MÉPRIS À LAFACE
JAMES ENSOR

law was finally passed in Belgium, Ensor painted a second version of *The Vile Vivisectors*. This second version almost entirely corresponds with the first, from which we may infer that the artist probably thought the bill would change nothing.

When commercial development endangered the dunes of Ostend or its city-scape, Ensor was again there with a critical opinion, publishing pamphlets in a language rich in verbal invention and imagery. He was also an impassioned speaker who took advantage of every opportunity to express his stance publicly. His love of language was great: "I love you, you words, red and yellow like the lemons of Spain, words like the steel blue of graceful flies, fragrant as flowing silk... words of the wind, words of the reeds, wise words of children, words of the rain and weeping words, you words without rhyme or reason, I love you, I love you". Ensor viewed himself as an "apostle of a new language." In his ambivalent oral discourses – what began as a paean of praise might abruptly flip over into an invective – he showed the same contradictoriness and inconsistency that inform his paintings. Unfortunately Ensor's writings and correspondence have been edited only in part, but what has been published to this point indicates the extraordinary inventiveness of his activities in this area.

Much the same could be said about the field of music, which Ensor ad-dressed, and satirized, again and again in paintings (*The Grotesque Singers*, p. 76; *The Frightful Musicians*, p. 85). Ensor was extremely musical, though he could not read notes. His involvement with music was intuitive. He played flute

The Vile Vivisectors, 1925
Oil on canvas, 62 x 80 cm
Private collection

Even in old age Ensor continued to take a stance on the social and political issues of the day. Here he sides with the initiators of a law to prohibit medical and zoological experiments on live ani-mals. The "crucified" dog in the upper center exemplifies the drastic methods then in common use, which, to Ensor's indignation, were not even questioned by the Church.

Mantlepiece in Ensor's living room, c. 1930

and piano, and when M. and Mme. Lambotte gave him a harmonium in 1903, Ensor taught himself to play it. The harmonium – the artist called it "the precious companion of my solitude" – was an unfailing source of consolation in his artistically and personally unsatisfying situation. In 1911 Ensor composed (in minor, as he insisted on playing only the black keys) music for a ballet pantomime, *Love Play*, for which he also designed stage and costumes. Apparently he strived to create a kind of "Gesamtkunstwerk" in which a variety of means of artistic expression would be combined in a comprehensive and mutually fructifying context. But in music as in painting, Ensor's work once again met with incomprehension. In Paris no one could be found to perform it, and it was not until 1924 that *Love Play*, at the instigation of Francois Franck, was premiered at the Antwerp Opera.

In the year 1917 Ensor's domestic situation changed. After the death of his mother and aunt he finally, aged fifty-seven, left his parents' house and the mansard studio he had used for decades. He moved diagonally across the street to No. 27 Rue de Flandre, a modest middle-class house inherited from his uncle which likewise had a toy and souvenir shop on the ground floor. Ensor let the shop continue business and furnished the remaining rooms for his own occupation and work. Here he would live, cared for by two servants, until his death. Ensor now began to receive increasing numbers of visitors, who frequently asked him to play something for them, which he was only too happy to do. His gift of improvisation and his impetuous temperament amazed the artist's guests. As one of them, the musician August de Boeck, once admitted, "Ensor knows absolutely nothing about musical technique, but he is a musician."

In what seemed like a mockery, the artist, now almost seventy years old, was finally accorded what he had dreamed of for half a lifetime: a spate of public honors. In 1929 King Leopold II named him a baron, whereupon Ensor promptly destroyed all still available impressions of the print *Doctrinaire Nourishment* (p. 8). In 1931 a monument was raised to him in Ostend. The 1920s witnessed a series of large Ensor exhibitions, and in 1933 the artist was named a member of the Legion of Honor.

Chinoiseries, 1907
Oil on canvas, 62 x 75 cm
Deurle (Belgium), Museum Dhondt Dhaenens

By the time this canvas was executed, Ensor had developed a solid repertoire of themes within the classical genres of landscape, cityscape, still life, and portraiture. To admirers and potential buyers like François Franck of Antwerp he made corresponding offers of "commissioned works."

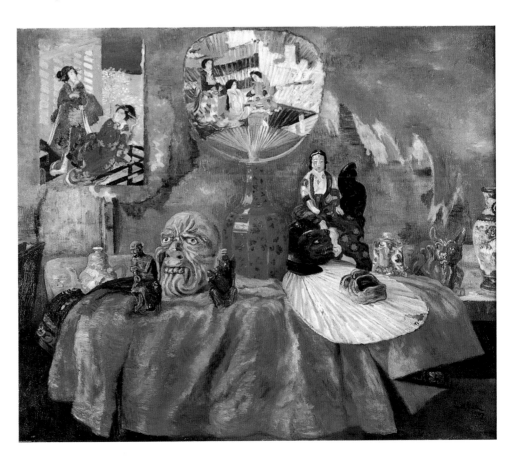

He was observed on his daily walk along the promenade at Ostend, a white-haired old gentleman invariably dressed in black, a dignified figure. At his house, filled with copies of his paintings and rare and strange curiosities, Ensor held court, received artists, scientists, writers, and politicians. The German art historian Werner Schmalenbach has described his visit to the eighty-five-year-old artist as a highly curious experience, seeing as Ensor had already stylized himself into a living legend. "All the oppressive absurdities do not seem ridiculous to us in the least. We are caught in the spell of a man hopelessly wound up in himself – a man who shares his almost otherworldly solitude shared only with his world-renown, his pictures, and an old servant."

In 1942 Belgian radio announced the death of Ensor – erroneously, as it turned out. The artist, who had spent his entire life feeling under attack from the powers that be, positively relished the mistake and permitted himself the fun of visiting his own monument with a black ribbon on his sleeve. "I am mourning myself," he joked when he met anyone. Death came finally to Ensor at the age of nearly ninety on November 19, 1949. He was given a grand state funeral, and the sympathy of the entire country went with him.

Ensor's belated recognition did little to change the fact that he remained an outsider throughout his career. He neither established a school, nor did he actually teach students who might follow in his footsteps. Yet though he was the quintessential lone wolf of art, Ensor's œuvre, partaking of both tradition and vanguard, influenced many artists of the twentieth century: Emil Nolde recognized Ensor's expressive imagination and received strong impulses from him for his own mask paintings. Paul Klee found in Ensor's graphic art and his use of line as an autonomous pictorial element a new path for his own art. George Grosz and Alfred Kubin were inspired by Ensor's depictions of masses and by his black humor. Felix Nussbaum, who when the Nazis came to power took refuge in Belgium, found stimuli in Ensor's skull and mask motifs; Bernard Schulze, better known as Wols, admired Ensor's phantasmagorias and quoted them in his paintings.

The provoking stylistic and thematic variety of his œuvre, which contained nothing his contemporaries could associate with conventional stylistic unity, even today still hampers a proper appreciation of Ensor's art and is probably the

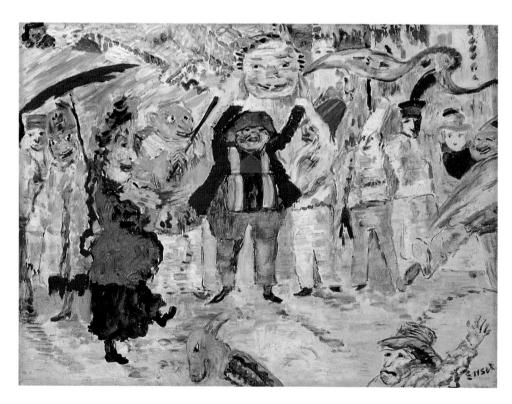

Carnival in Flanders, after 1920
Oil on wood panel, 27 x 36 cm
Zurich, Kunsthaus Zürich

In the final years of his life Ensor frequently returned to themes from earlier paintings or quoted certain passages from them.
Here the bright, forceful colors seem to set the surrounding scene in motion, while the figures appear caught in a state of suspended animation.

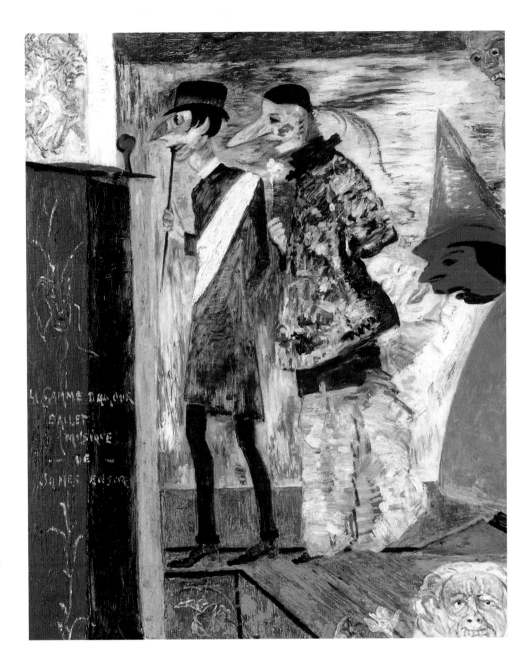

Figures in Front of the Playbill of La Gamme d'Amour, c. 1925–1929
Oil on canvas, 86 x 71 cm
Brussels, Musées royaux des Beaux-Arts de Belgique

Here Ensor quotes the figures of onlookers who stood on the dais in *The Entry of Christ into Brussels*. Their interest is no longer in Christ-Ensor but in a ballet-pantomime composed by the artist in 1911, *La Gamme d'Amour* (The Game of Love), to which the poster refers.

reason why many persist in considering him no more than a marginal figure in the history of European art. A great proportion of his life's work is in private collections, and is thus inaccessible to the public. With the exception of Belgian museums, most public collections worldwide contain at most a single Ensor, which in no way does justice to the complexity of this artist.

Ensor's largest and most important painting, *The Entry of Christ into Brussels*, now hangs in one of the most recently established museums in the United States, where it forms a superb culmination of a review of nineteenth-century art.

"Sometimes," Ensor wrote in 1925, in a speech to be given on the occasion of his acceptance into the Académie Royale de Belgique, "being someone who has a hard time bearing many things, I have had... to maneuver with and against them all: head or south winds, equinoctal floods, currents hot and cold, but never temperate... At moments I have glimpsed the Flying Dutchman, the many-tentacled squid, Sinbad the Sailor, and the great sea serpent, and the old, horrible quid-stuffed pirates of Ostend have offered me many a too pungent pinch of snuff.

"I have steered my barque decked with inkily adjectified pennants, sails billowing, towards the coast of Hoaxland and palipitating inquietudes."

Life and Work

1860 James Ensor is born on April 13 in Ostend. His father, James Frederic Ensor, is an engineer of British extraction; his mother, Maria Catharina Haegheman, is a native of Ostend and proprietress of a souvenir shop that sells Carnival masks, seashells, Chinese goods, etc.

1861 Birth of Ensor's sister, Mariette ("Mitche"), who in later years will frequently sit to him for oils and drawings.

1873 Spends two years at Notre-Dame secondary school in Ostend. Receives instruction from two local artists, Edouard Dubar (1803–1879) and Michel Van Cuyck (1797–1875).

1875 The family moves to the corner of Rue de Flandre and Boulevard van Iseghem, where Ensor will live until 1917.

1876 At age 16, executes first small paintings on cardboard, depictions of dunes, seascapes, and polder landscapes done outdoors. Takes drawing courses at Ostend Academy.

1877 Ensor studies at Académie Royale des Beaux-Arts, Brussels, and meets painters W. Finch, F. Khnopff and G. Vogels. Develops friendly relations with the Rousseau family, who introduce him to the intellectual and anarchist milieu of Brussels. Meets Eugène Demolder, who in 1892 will write the first Ensor biography.

1880 Returns to Ostend, but continues to maintain contacts with his Brussels friends. Furnishes a studio in the attic of his parents' house and paints realistic portraits and Impressionist-influ-

Ensor with Ernest Rousseau in the dunes outside Ostend, 1892

enced landscapes: *The Lamp Boy, Rue de Flandre in the Snow*.

1881 First exhibition with the Belgian avant-garde group "La Chrysalide" in Brussels. Paints interiors in dark, sombre hues: *Afternoon in Ostend, The Bourgeois Salon*.

1882 Shows at the Paris Salon and with the Brussels art society "L'Essor," where one critic calls his works "trash." Paints *The Oyster-Eater*, which is rejected by the Antwerp Salon.

1883 Octave Maus establishes "Les Vingt," a group of progressive artists including Khnopff, Finch, van Rysselberghe and Vogels, with which

Ensor will frequently exhibit. Executes his first mask painting, *The Scandalized Masks*, and his famous *Self-Portrait*, to which the flowered hat will later be added.

1884 Travels to Holland and Paris. All of Ensor's submissions to the Brussels Salon are rejected. The journal *L'Art Moderne* publishes a satire by the artist on his experiences at the academy.

1885 Fantastic motifs begin to enter the imagery: *Skeleton Looking at Chinoiseries, The Haunted Dresser*.

1886 First etchings: *The Mocking of Christ, The Cathedral*. Tensions within "Les Vingt" lead to Ensor's increasing isolation.

1887 Death of his father (at 52) and his maternal grandmother. Ensor's dark phase seems over; he paints light-hued, phantasmagorical landscape visions: *Tribulations of St. Anthony, Adam and Eve being Expelled from Paradise*.

1888 Ensor's major work, *The Entry of Christ into Brussels in 1889*, is executed. He meets Augusta Bogaerts, an innkeeper's daughter whom he nicknames "the siren." She will remain a life-long friend.

1889 *The Entry of Christ into Brussels in 1889* is rejected by "Les Vingt," who consider expelling Ensor from the group. Numbers of mask paintings: *Old Woman with Masks, The Astonishment of the Mask Wouse*.

1892 Four-day trip to London. Ensor's sister Mitche marries a Chinese, who, however, abandons her shortly after the wedding. Mitche's daughter, Alexandra, is born. Ensor contracts pneumonia.

Ensor in his studio, 1889

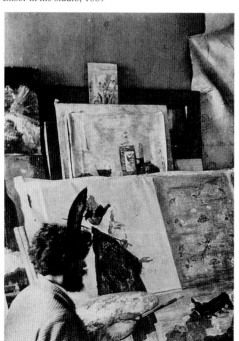

Ensor, c. 1880

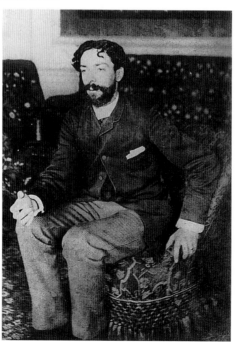

1893 Final exhibition of "Les Vingt." Ensor's isolation grows. He attempts to sell the contents of his studio for 8,500 francs, but finds no takers.

1894 Disbanding of "Les Vingt" and establishment of the group "La Libre Esthétique."

1895 The Brussels museum purchases *The Lamp-Boy*. The department of prints and drawings acquires etchings. First one-man exhibition in Brussels, mounted by Eugène Demolder in his father's counting-house.

1898 First small one-man show at the "Salon des Cent" in Paris. It remains without echo.

1899 The Paris journal *La Plume* devotes a special issue to Ensor, which attracts little attention at the time of publication. Fifty-two graphic works are shown at the "Cercle Artistique" in Ostend. The department of prints and drawings at the Vienna Museum acquires c. 100 etchings.

1903 The artist is named a Knight of the Order of Leopold.

1904 He meets the author Emma Lambotte. She and her husband purchase numbers of Ensor's paintings.

1905 Emma Lambotte introduces Ensor to François Franck, who defends and furthers his work. Franck organizes exhibitions with "L'Art Contemporain." Thanks to his donations numerous of the artist's works will later enter the Antwerp Museum.

1906 The Lambottes give Ensor a harmonium, which from now on he will spend a great deal of time playing.

1908 Emile Verhaeren writes a monograph on the artist which will subsequently influence many biographers. Ensor's niece Alexandra marries, at age 14, Richard Daveluy, who is unemployed. The tie causes Ensor much worry.

1909 Alexandra bears a son, Jules, to Daveluy. Emil Nolde, the German Expressionist, visits Ensor at Ostend, an experience which will influence his own figurative and mask paintings.

1911 Ensor composes the music, writes the libretto, and designs the sets for a marionette play, "La Gamme d'Amour".

1914 Not heeding his friends' advice, the artist remains in Ostend during the war.

1915 Ensor is arrested for having insulted Kaiser Wilhelm II. His mother, whom he has nursed for a long period, dies at age 80.

1916 Death of his beloved aunt Mimi.

1917 Ensor inherits from his uncle Leopold Haegheman a house on Rue de Flandre, and moves there. He retains the ground-floor souvenir shop, but does not open it to the public. He will spend the rest of his life in this house, cared for by two servants.

1920 First public successes and major retrospective at Galerie Giroux in Brussels. Ensor sold six works to the Musée royaux in Brussels Paul Colin publishes an Ensor monograph in Germany.

1921 Important Ensor exhibition in Antwerp.

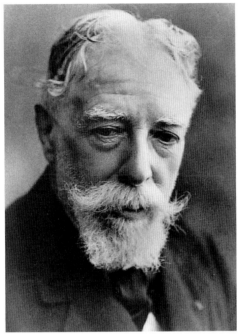

Ensor, c. 1940

François Franck donates eight works to the Antwerp Museum.

1922 The Plantin-Moretus Museum in Antwerp acquires the artist's entire graphic œuvre.

1925 The complete graphic work is edited by Loys Delteil.

1926 Works shown at the Belgian Pavilion at the Venice Biennale.

The artist's calling card

1927 First Ensor exhibition in Germany, at the Kestner-Gesellschaft, Hanover (later in Berlin and Dresde). It comprises 50 paintings and the entire graphic œuvre.

1929 King Albert confers the title Baron on Ensor. *The Entry of Christ into Brussels in 1889* is publicly exhibited for the first time at a retrospective in the Brussels Palais des Beaux-Arts.

1923 Ensor exhibition at the Jeu de Paume, Paris.

1933 Ensor is proclaimed "Prince of Painters" in Brussels and is awarded the Band of the Legion of Honor by France.

1940 During a German bombardment three paintings and numerous etchings are destroyed in the Ostend Museum.

1942 Belgian radio erroneously announces the artist's death.

1945 His sister Mitche dies at age 84.

1946 Exhibition at the National Gallery, London: "The Works of James Ensor".

1948 Founding of "Les Amis de James Ensor," an organization devoted to furthering his art and erecting an Ensor museum in Ostend. (In the 1950s, in collaboration with the City of Ostend, this society would inaugurate a museum in the artist's house containing graphic works, several copies of his paintings including *The Entry of Christ into Brussels in 1889*, and countless mementoes.)

1949 After a three-week illness Ensor dies on November 19. He is buried in the cemetery of Notre-Dame des Dunes, in Mariakerke near Ostend.

JAMES ENSOR
Artiste-Peintre
23, Rampe de F....e, Ostende

Photo credits

The publishers would like to thank those museums, archivists, collectors and photographers who gave permission for the reproduction of the illustrations and supported the production of this work. Special thanks to Sophie Van Vliet (attached to the Musées royaux des Beaux-Arts de Belgique, Brussels), Xavier Tricot and Patrick Florizoone.
In addition to those persons and institutions cited in the legends to the pictures, the following should also be mentioned.

Archiv für Kunst und Geschichte, Berlin: 42; Bibliothèque Royale Albert 1, Brussels: 45; Brussells, Collection Crédit Communal - Dexia: 31 above, 52, 73; California: 46/47, 48 left & right; Collection Mira Jacob, Paris: 8 above, 51, 84 (Photo Boris Veignant: 51); Courtesy

Christie's, Amsterdam: 90; Courtesy Galerie Ronny van de Velde, Antwerp: 55; Courtesy Takika, Paris: 64 below; Ensoreanum, Collection Xavier Tricot, Ostend: 7, 40; Fondation Socindec, Vaduz: 23, 41; James Ensor Archief, P. Florizoone, Slijpe (Belgium): 2, 12 above & below, 28 below, 45 center, 53, 71 below, 82, 89 below, 94 below, 95; Kimbell Art Museum, Fort Worth, Texas, Photograph Michael Bodycomb: 65; Koninklijk Museum voor Schone Kunsten, Antwerp: Cover, 1, 11 above & below, 14, 16, 17, 24, 29, 30 below, 39, 50, 57-61, 72, 74, 81, 89 above; Kunsthaus Zürich, Zurich: 6, 34, 92; Michael Konze: 64 above; Musée d'Art moderne et d'Art contemporain de la Ville de Liège, Liège: 70; © Musée des Beaux Arts, Tournai: 25; Musée d'Orsay, Paris, © Photo RMN - Jean Schormans: 32; Musées royaux des Beaux-Arts de Belgique, Brussels, Photo Cussac, Brussels: 18,

19 below, 69; Musées royaux des Beaux-Arts de Belgique, Brussels, Photo d'art Speltdoorn et fils, Brussels: 13, 38, 56, 66, 77, 93; Museum Dhondt-Dhaenens, Deurle (Belgium): 91; © Museum Folkwang, Essen: 68; Museum voor Schone Kunsten, Ghent: 43, 44, 63; Museum voor Schone Kunsten, Ostend: 9, 20, 21 below, 45 above, 51, 54, 71 above left & right, 75 above & below, 83 center & below, 88; Neue Pinakothek, Munich, Blauel/Gnamm - Artothek, Peissenberg: 62; Philadelphia Museum of Art, The Louis E. Stern Collection, Philadelphia, Pennsylvania: 86; Photo Antony, Ostend: 49, 87; Städtische Kunsthalle, Mannheim: 67 above right; The J. Paul Getty Museum, Malibu; The Museum of Modern Art, New York, Photograph © 1998 The Museum of Modern Art, New York; Wallraf-Richartz-Museum, Cologne, © Rheinisches Bildarchiv, Cologne: 26, 35